BRITAIN IN OLD

AROUND LEWISHAM & DEPTFORD

JOHN COULTER

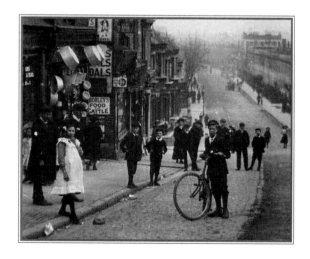

First published in 2005 by Sutton Publishing
Reprinted 2007

Reprinted in 2013 by
The history Press
The Mill, Brimscombe Port,
Stroud, Gloucestershire, GL5 2QG
www.thehistorypress.co.uk

Title page photograph: Clifton Hill, *c.* 1919.

British Library Cataloguing in Publication Data
A catalogue record for this book is available from the
British Library.

ISBN 978-07509-4136-5

Typeset in 10.5/13.5 Photina.
Typesetting and origination by
Sutton Publishing.
Printed and bound in Great Britain by
Marston Book Services Limited, Didcot

For Richard White

CONTENTS

Preface 5

Acknowledgements 6

Maps 7

1. Highways 15

2. Houses 27

3. Denominations 37

4. Education 47

5. Fresh Air 57

6. Fun & Games 67

7. Byways 79

8. Trade & Industry 91

9. Amenities 103

10. Housing 113

11. First World War 121

12. Looking Down on Lewisham 129

 Index 141

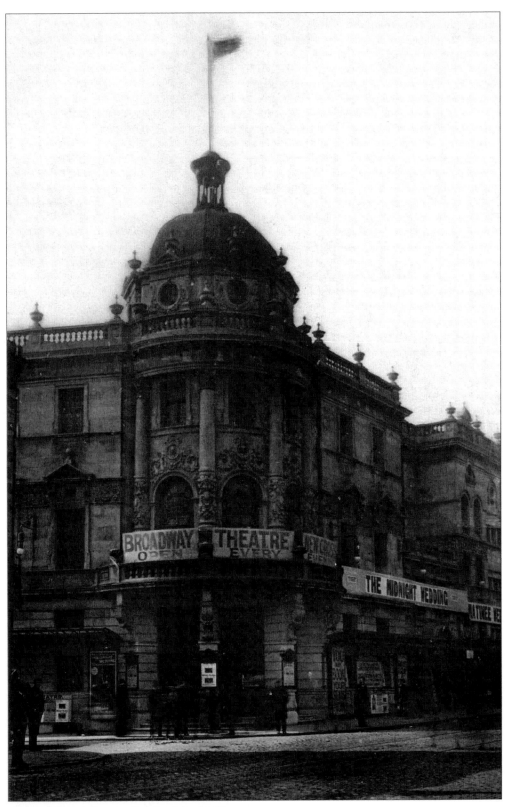

The Broadway Theatre, Deptford, in 1909.

PREFACE

After fifteen years, eight volumes, and one thousand five hundred and eighty-six old Lewisham photographs I did not anticipate troubling the reading public with yet another in the series. The event that changed my mind was the decision of my old friend and collaborator Barry Olley to leave Lewisham and sell his fine postcard collection. The hundred cards I bought from him are the solid foundation of this book. With those and an equal number from my own stores I was confident that something up to the standard of the previous volumes could be put together.

When work was already well advanced another friend, Richard White, invited me to examine his extensive collection, and generously allowed me to include as many postcards as I liked in the forthcoming book. It was hard to choose amid such riches, but eventually, with uncharacteristic self-discipline, I limited myself to only twenty-five or thirty. Many of the plums of the volume are to be found among them. They enable me to claim that for the variety and quality of the images Around Lewisham & Deptford is as good as the best of its predecessors. It adds exactly two hundred to the already surprising total of published old Lewisham photographs. The title might just as well have been *Lewisham & Deptford: A Fourth Selection*, as it follows the pattern of those volumes closely.

Readers and authors will not always agree in their choice of the outstanding pictures in a book of this kind. The reader will usually opt for striking images, while the author will be looking for ones that are unique or at least very unusual. In this category I would particularly commend Brook House (p. 33), the old Catford Salvation Army hall (p. 37), the London City Mission (p. 46), the King of Belgium and the old Joiner's Arms (pp. 68 and 69), and the Obelisk Picture Palace (p. 76), all records of buildings long vanished and not previously seen in clear photographs. The pictures of the Park Hospital ward (p. 106) and the Lewisham Hospital operation (p. 124) are valuable additions to the store of local medical history, and the view of Darling's committee rooms (p. 108) gives a rare glimpse of the lively political life of Deptford in its early days as a constituency. My particular favourites are the records of the fading rural life of Lewisham: Hazel's tea garden (p. 62), Perry's watercress beds (p. 57), and above all the panorama of the fields of Bellingham (p. 122) a few years before the building of the great London County Council estate.

This time I have not included cross-references to the earlier old photograph books, as most are now out of print and hard to obtain. For the record they are, in

chronological order: *Lewisham & Deptford in Old Photographs* (1990, revised 1992), *Lewisham & Deptford: A Second Selection* (1992), *Sydenham & Forest Hill*, with John Seaman (1994, revised 1995), *Lewisham*, with Barry Olley (1995, revised 1998 and 2003), *Lewisham & Deptford: A Third Selection* (1997), *A Century of Lewisham* (1999), *Lewisham Past & Present* (2001), and *Forest Hill & Sydenham*, with John Seaman (2003). I am seriously thinking of producing a master index to them, as it takes longer and longer to locate required images. A large proportion of Lewisham streets, buildings, and institutions must by now have been represented somewhere in the series. Work on this book would have been abbreviated if I had always been able to find previous captions on similar subjects.

As the map included in *Forest Hill & Sydenham* proved a popular innovation, I have here reprinted the complete Lewisham and Deptford section from the same Bartholomew's atlas. The copy used was a gift from Phillip Woollard, the most genial and companionable of men, whose sudden death last year eclipsed the gaiety of Lewisham and Deptford.

ACKNOWLEDGEMENTS

I have to thank Richard White, John Seaman, and the Lewisham Local Studies Centre for the use of postcards and photographs from their collections, and Paul Dyer, the great expert on the subject, for providing information about war memorials. As always, I have derived great benefit from the books on Blackheath by Neil Rhind, on local cinemas by Ken George, on Lewisham buildings by Darrell Spurgeon, on Hither Green by Godfrey Smith, on Lewisham's pubs by Ken White, and on Grove Park by John King.

The maps are from J.G. Bartholomew's *Handy Reference Atlas of London and Suburbs*, 4th edition, 1921.

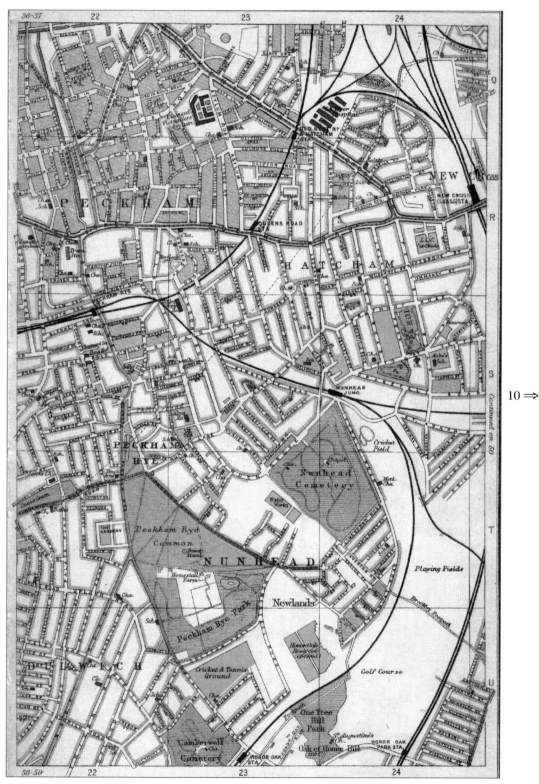

10 ⇒

Continued on 50

New Cross.

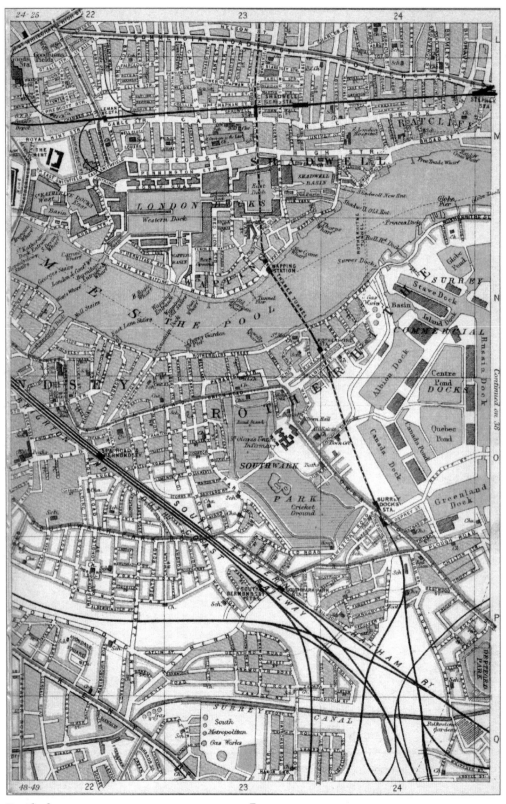

Deptford.

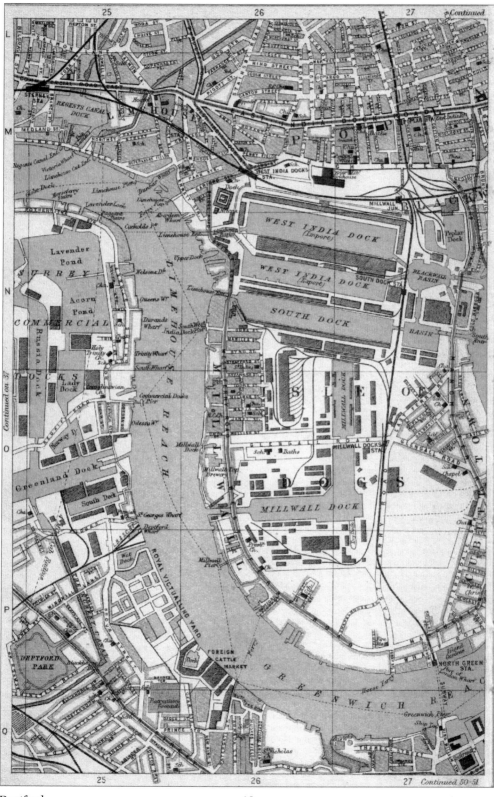

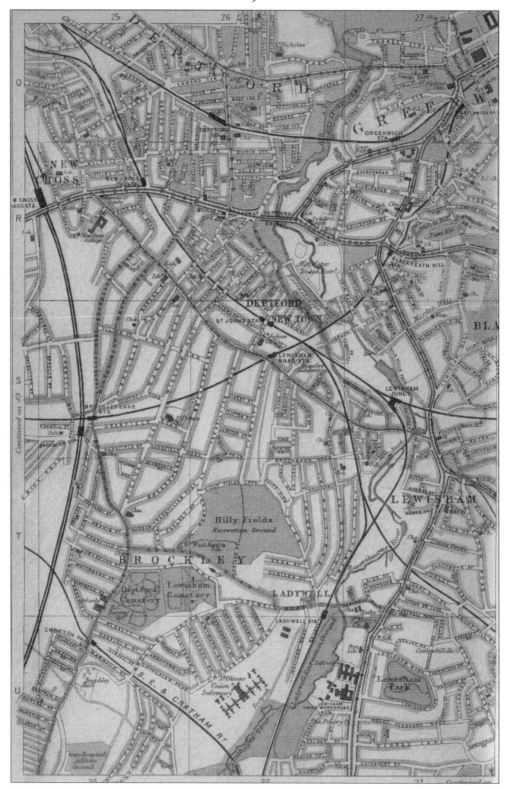

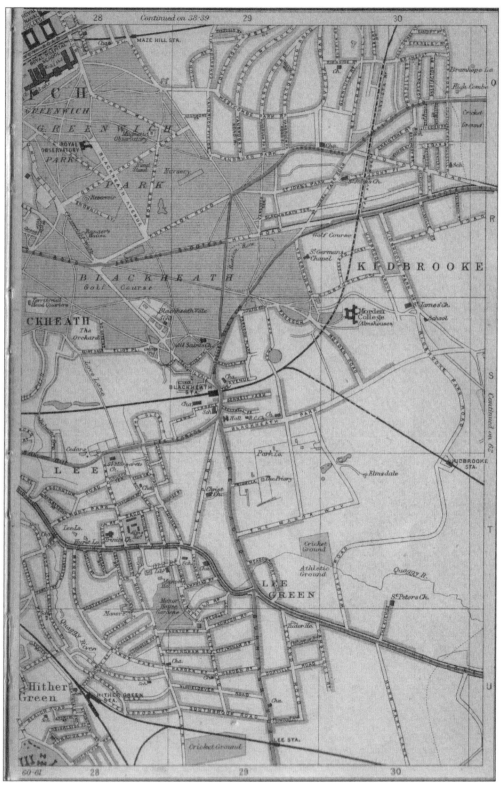

Blackheath & Lee.

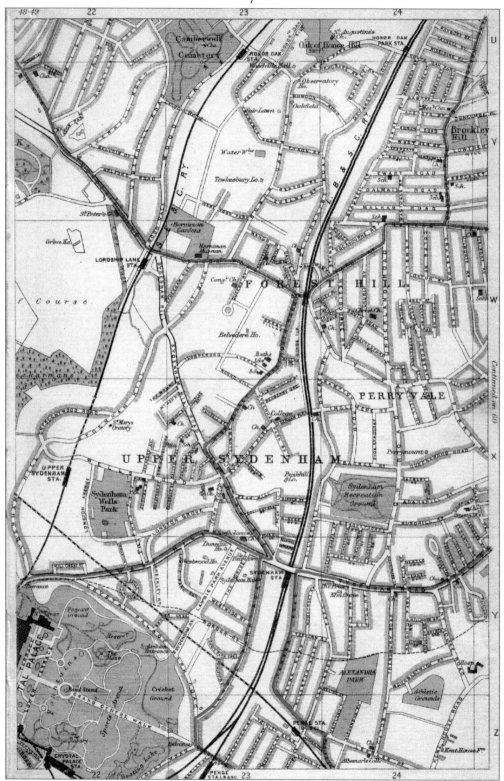

Sydenham & Forest Hill.

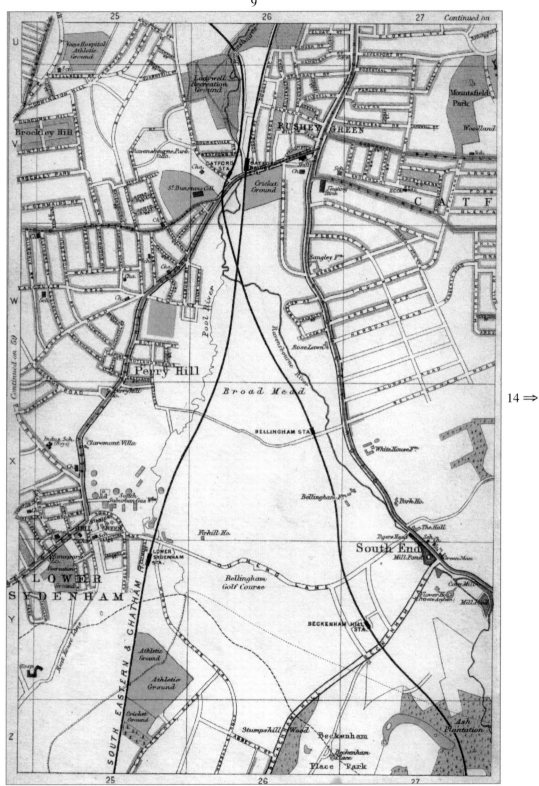

Continued on

Continued on 59

14 ⇒

Catford & Southend.

⇐ 13

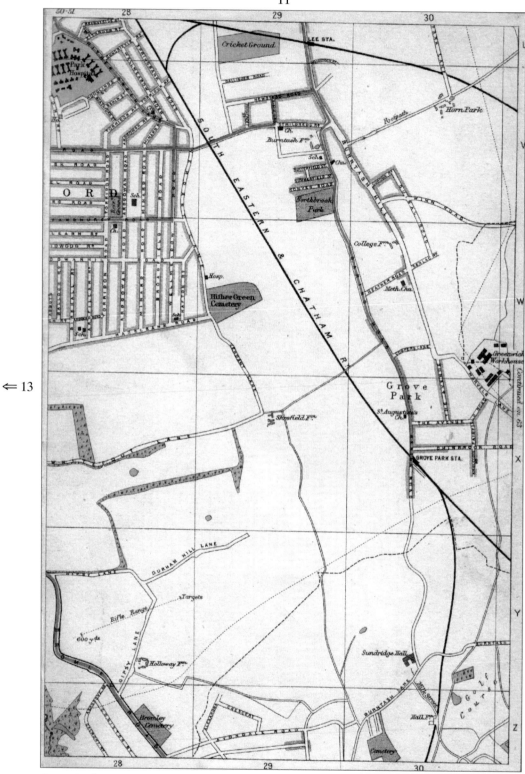

Grove Park.

1

Highways

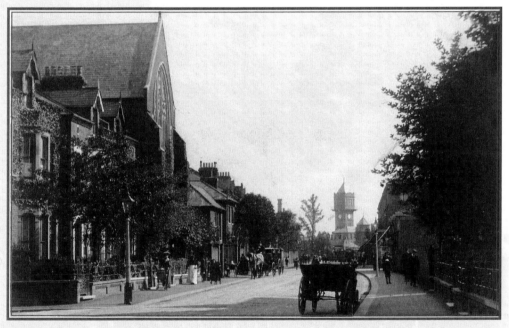

This Edwardian photograph shows Hither Green Lane from the corner of Ennersdale Road.
It was perhaps taken on a Sunday, to judge from the costumes and the bustle
outside St Swithun's Church. In the distance is the water tower of the Park Hospital,
a landmark now increasingly obscured by the mushroom growth of the new flats
on the hospital site.

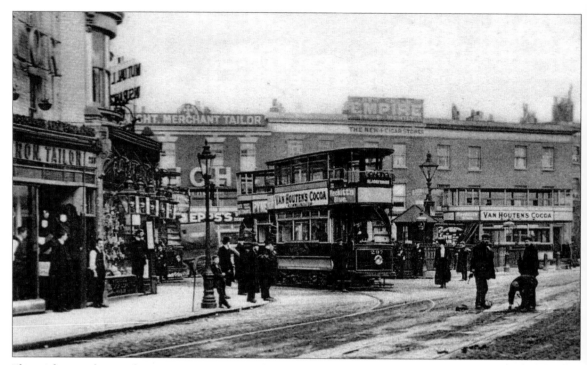

The mishap to the tramlines at New Cross Gate that attracted the attention of this photographer in 1910 was apparently interesting enough to bring the shopkeepers to their doors. The view is from Queen's Road. All to the left of centre remains intact, but the two shops to the right of the New Cross Cigar Stores, which had long served as the London & South Western Bank, a forerunner of Barclays, were soon to be rebuilt in monumental style. The houses on the far right were destroyed in the Second World War, and replaced by the post office.

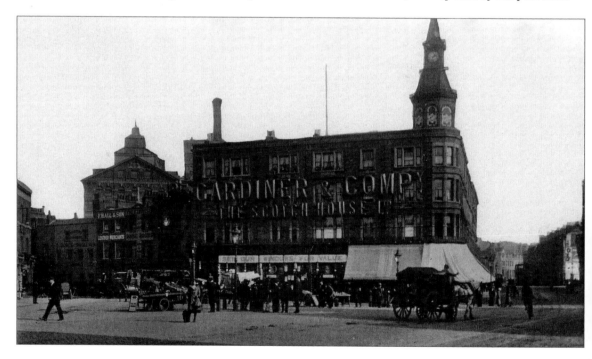

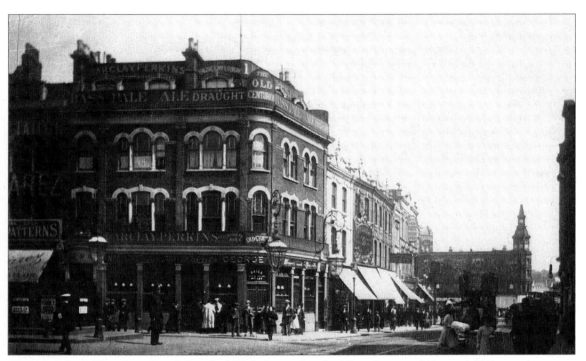

The spot where New Cross Road, Deptford High Street, Deptford Broadway and Tanner's Hill meet has some claim to be the heart of Deptford, a status perhaps recognised by the council when it placed an anchor here as a symbol of the town's former maritime importance. The junction was as central when this photograph was taken in 1923 as it is today, but historically the road to the bridge was far from Deptford's riverside origins, and until the eighteenth century the Broadway was a distinct settlement separated from Deptford Strond and the Thames by open fields. The view here is from New Cross Road towards the Broadway and Deptford Bridge, with the entrance to the High Street on the left. The tower in the distance was part of the Scotch House, for which see the opposite page. As its business was to look after travellers between London and Dover, the Broadway was a great place for public houses, now all demolished or closed. Two can be seen in this picture. The older and more celebrated was the Dover Castle, the tall white building with the sign, just to the left of the Scotch House, which had been an inn since the fourteenth century. It was destroyed by a mysterious explosion in 1990, a judgement perhaps on those who had changed the name to the Broadway Tap. The Old Centurion at the corner of the High Street and the Broadway is a more recent casualty, though it has only suffered the commonplace fate of closure and dereliction. It was known as the Royal Oak in 1757, but had become the Centurion by the beginning of the nineteenth century.

Opposite, bottom: The Scotch House, Gardiner & Co.'s huge drapery shop at the corner of Deptford Broadway and Deptford Bridge, must have shocked many old residents when it replaced numerous ancient shops and pubs in 1882–3. But architects love to illustrate the moral that things can always get worse. The building now on the site makes Gardiner's shop seem a miracle of grace and modesty. The part of the Broadway in the foreground was a street market when this postcard was published before the First World War. For the great mills looming in the background see pp. 92 and 132.

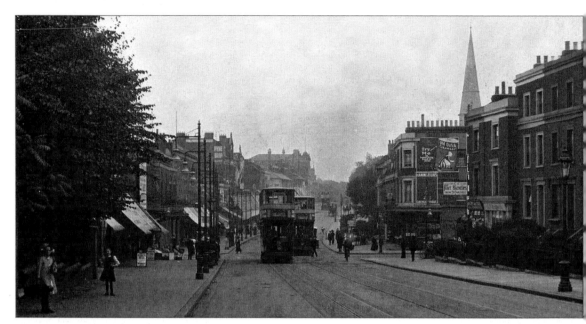

Lewisham High Road, or Lewisham Way as it has been called since 1939, is seen here in 1912 or thereabouts from the corner of Amersham Road. The two trams were at the Malpas Road/Florence Road junction. It must have been as hard to believe then as it is now that this dip was a river valley, and that the road once crossed a bridge.

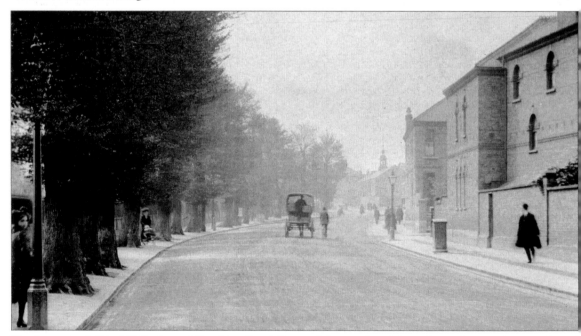

The interest of this 1910 view of Brockley Road lies mainly on the right, where the two houses, 1 and 2 Whitbread Road, were destroyed by a flying bomb in July 1944. Half of Whitbread Road and parts of Comerford and Dalrymple Roads were laid waste in this attack. Brockley Road School, Will Hay's unlikely alma mater, was also flattened during the war. Its turret can be seen in the distance. The trees on the left screened the wall of Brockley Cemetery.

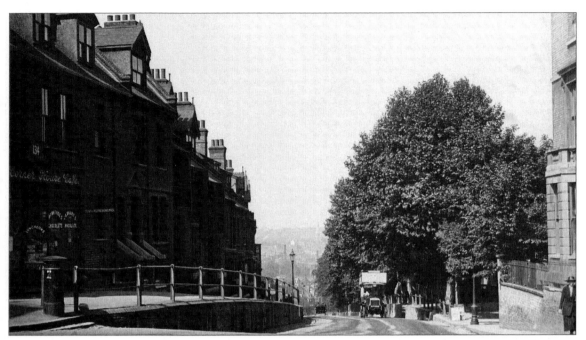

Blackheath Hill, so hard to climb, so easy to descend, separates wealthy Blackheath from impoverished Deptford. This early 1920s photograph was taken from the top. The café on the left was at the corner of Dartmouth Row; the house on the right was 23 The Grove, now West Grove. It was demolished in the late 1930s. The brave photographer was standing on the Lewisham–Greenwich boundary, which at this point follows the middle of the road.

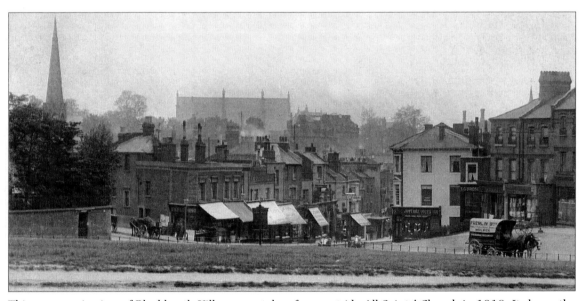

This panoramic view of Blackheath Village was taken from outside All Saints' Church in 1910. It shows the end of Royal Parade and the entrance to Tranquil Passage on the right, with the corner of Wemyss Road on the left. In the centre is Montpelier Vale, with the roof of the Blackheath Concert Halls looming behind it. The spire on the left belonged to the Wesleyan Church in Blackheath Grove, which was destroyed by a V2 rocket in March 1945, along with many of the visible shops in Montpelier Vale.

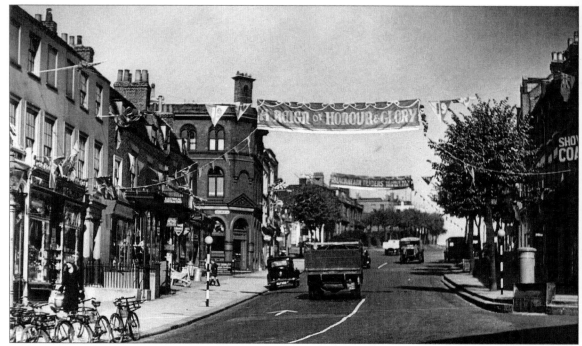

The Silver Jubilee of King George V in May 1935 was celebrated all over the country – all over the empire – with bunting, beacons, and cheap mementos. In Lewisham there were numerous street parties, especially in the poorer areas. The town hall at Catford was fancifully decorated, and St Dunstan's College illuminated by electricity. In the main roads the shopkeepers proclaimed their loyalty and opportunism with gaudy banners across the streets and equally loud displays in their windows. One Blackheath greengrocer had his oranges wrapped in alternate red, white and blue tissue paper. All the high ground of the district was occupied by the proprietors of competing beacons. The Lewisham Boy Scouts constructed their bonfire at the Point, Blackheath, and after a torchlight procession across the Heath they set it ablaze 'electrically, following the example of H.M. the King at Hyde Park'. This photograph shows Tranquil Vale decorated for Jubilee week by the Blackheath District Traders' Association. The Blackheath Local Guide reported that 'ten banners in blue and gold hung across the main thoroughfares'. They cost the shopkeepers a total of £60.

Opposite, top: This glimpse of Lewisham High Street in the 1870s features the part that was devastated by the market flying bomb. By that time much on the left of the picture had already been changed by commercial forces, but the Albion pub on the right and most of the shops beyond it survived until 1944. The saddest loss – a much earlier one – is that of Allen's Green, the grove of trees at the northern end of what is now the market. It was named after the family of lawyers that owned the old houses sheltered by these trees from the intolerable bustle of the High Street. See p. 33.

Opposite, bottom: This postcard shows the same part of the High Street from the opposite direction. This time the Albion is on the left and the greens later colonised by the market traders on the right. The photograph was obviously issued at a time of patriotic enthusiasm, perhaps for the coronation of George V in 1911. It was certainly taken no later than the summer of 1912.

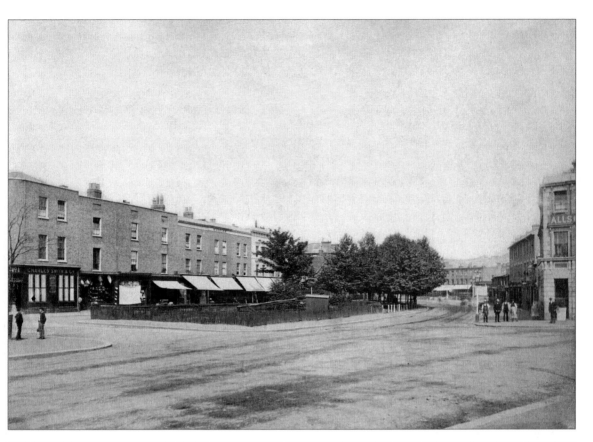

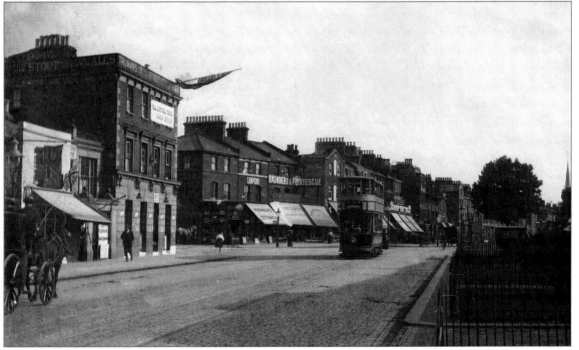

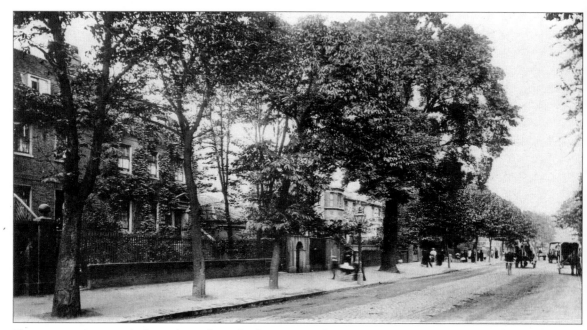

These two views north from the railway bridge in Lewisham High Street, recorded in 1906 and 1914, illustrate the speed of Edwardian change. The large semi-detached eighteenth-century houses on the left in the top picture were nos 244 and 242, known as Magnolia House and Bridge House. 'Bridge House' did not refer to the railway but to the owner of the estate, the Bridge House Corporation of the City of London. The houses were demolished in 1913 to make way for the shops seen below, the nearest one called the New Parade Café.

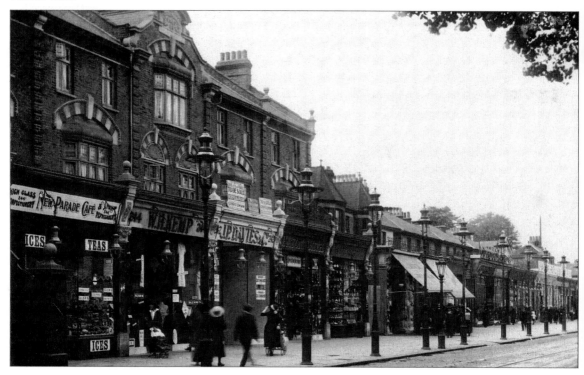

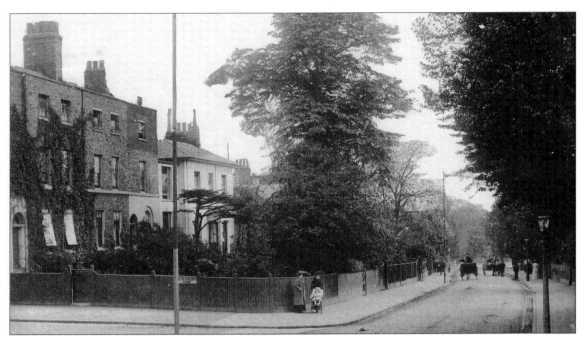

This photograph of Lee Road from the corner of Lee Terrace was taken in 1912. The Lewisham boundary runs down the middle of Lee Road, so the three houses on the left, just south of Blackheath Park, were in Greenwich. They were probably built in 1820. The nearer two, nos 37 and 39, known as Park Terrace, served for different periods as boarding houses for the Blackheath Proprietary School. No. 41 was a dentist's surgery in its later years. All three were demolished in the early 1960s to make way for the development of flats known as Spangate.

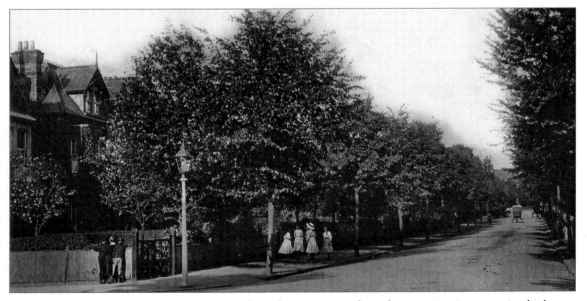

In 1912 St Mildred's Road was a quiet residential street, its undesired promotion into a major highway, now the South Circular, still twenty-five years in the future. On this summer day its pressing problem had nothing to do with traffic. How could a group of respectable young ladies best avoid ambush by the local William Brown and his gang?

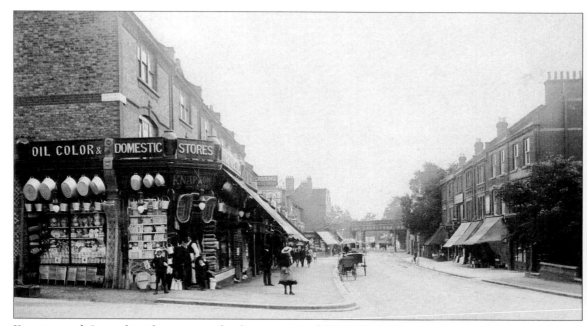

Knapton and Sons, the oilmen, were the first tenants of 36 Catford Hill, and remained from 1899 until 1925. The shop is on the corner of the second entrance from Catford Hill into Stanstead Road, which had long been a grassy lane, but was now moving towards its modern role as an important feeder to the South Circular. The shops on the right are 27 to 15 Catford Hill. The more distant five, originally called College View, were built in 1891, the nearer pair in 1897–8.

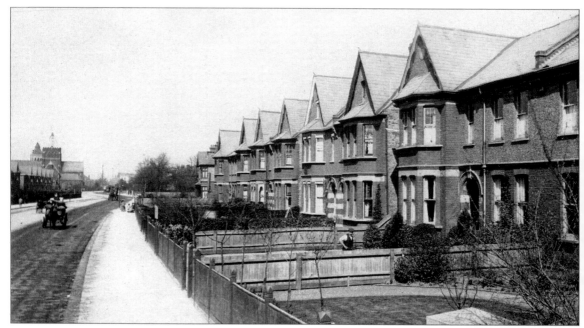

Bromley Road, Catford, is seen here in 1906, when this was the new frontier of Lewisham. The view is north towards St Laurence's Church and the town hall. The spanking new houses on the right – now nos 57 to 43 – had been built by James Watt of Sangley Road, one of the group of Scottish developers that transformed Catford between 1895 and 1914.

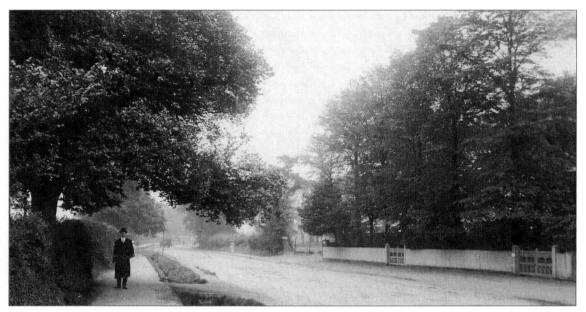

This photograph of a country lane called Bromley Road, Catford, was probably taken in 1907. The impression of rural peace was already somewhat illusory. The 'To Let' board outside Roselawn, one of the pair of old houses behind the trees on the right, was there because James Robertson had built his jam factory next door in 1900, and the well-supported Catford/Southend Football Club had established its ground in front of the factory. The gate on the right belonged to Ravensbourne Lodge, which had just become a laundry.

This early 1920s photograph of Bromley Hill, Lewisham's last gasp before it lapses into Bromley, shows the view down towards Southend Village. Behind the hedge on the right was Bromley Hill Cemetery, which had been opened in 1905 (within Lewisham) by Bromley Council.

Men or beasts may reasonably desire rest and refreshment when they reach this elevated spot, whether they approach it up Kirkdale (where this photographer was standing in the 1890s), or up Eliot Bank, Sydenham Rise or Sydenham Hill. Only to the left is Sydenham Hill flat, as it follows the ridge leading to Crystal Palace. Early in the nineteenth century a telegraph signalling station stood in front of Holly Brow, the house on the left. It is surprising that there was never a pub here. Nowadays there is not even a seat for the weary pedestrian.

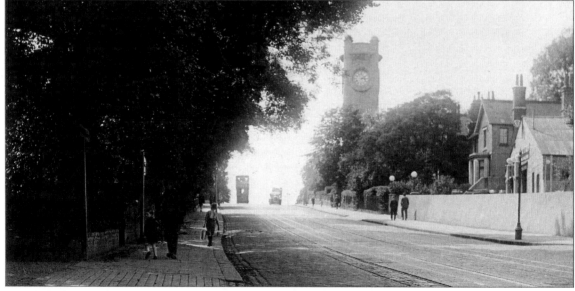

London Road, Forest Hill, is seen here from opposite Honor Oak Road in 1931 or a little earlier. Horniman's Museum dominated the road then as now. On the right was Squire and Earp's motor garage, the remote ancestor of the current petrol station. The house beyond it was Montreux Cottage, 88 London Road, which was destroyed by a flying bomb in March 1944. The little girl on the left was perhaps looking back wistfully because the cobbled entrance belonged to the forecourt of a sweet shop.

2

Houses

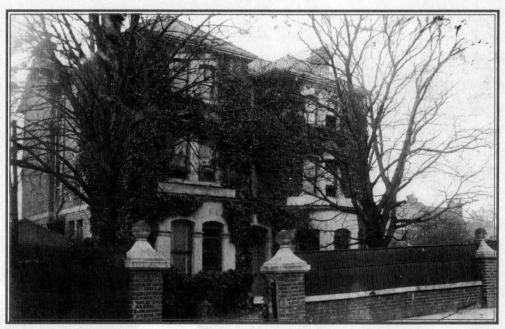

Grove Park House was 2 Chinbrook Road, the first on the south side, and
adjoining Grove Park station. This postcard was sent in 1917 by an
Army Service Corps soldier billeted there. Grove Park House and its neighbour
Craven House, the two biggest in the road, were demolished in 1938 to make way for
Chinbrook Crescent.

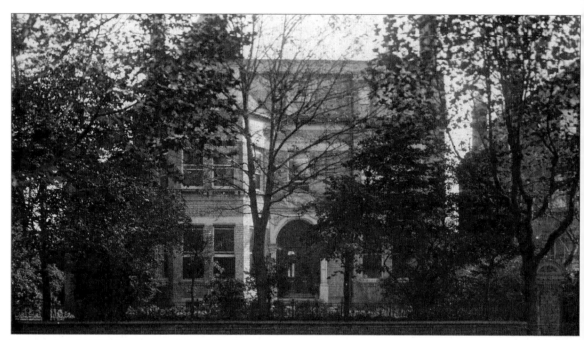

Edgcumbe, 57 Wickham Road, was built for the warehouseman Francis Leaver in 1879, when the Wickham-Drake estate was highly fashionable among commuters to the City. Brockley, St Johns, and the two New Cross stations were all nearby, but not obtrusive. Edgcumbe became a Goldsmiths' College hostel in 1919, when this postcard was probably issued, and still forms part of the enlarged Raymont Hall.

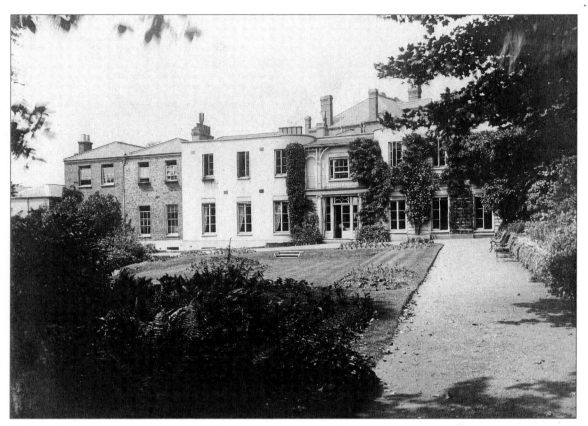

Cedar Lodge was sometimes considered part of Lewisham Hill, but was more often counted in Dartmouth Row, where it was numbered 50. The main frontage, though, was in Morden Hill. The regular late Georgian design of the original stuccoed villa (called Dell Lodge in its early days) had been disrupted by the dormitory wing on the left. That was added for Miss Frances Catherine Maberley, who ran Cedar Lodge as a ladies' school from 1859 until 1895. In this photograph from the garden, probably taken in the 1880s, the roof and chimneys in the background belong to 48 Dartmouth Row, on the far side of Morden Hill. In 1917 Cedar Lodge became the nurses' home of St John's Hospital, and in 1938 the futuristic new nurses' home designed by Bertram Carter was built along the line of this path. It linked Cedar Lodge, with all the tact of a Sainsbury Wing, to West Lodge (see p. 83), the next house down the hill. During the Second World War bombardment the substantially built Cedar Lodge and West Lodge were both too seriously damaged for repair, while Carter's mainly glass confection escaped unscathed. But if it could dodge bombs, it could not elude the developers who demolished all but one of the St John's Hospital buildings in 1989.

Opposite, bottom: St Peter's Villa, 54 Wickham Road, was built early in the 1870s for John Crow, a contractor's clerk. It lay well back, between Geoffrey Road and the railway cutting. The detached conservatory was behind the house, even further from Wickham Road. In this 1930s photograph the right-hand wall of the conservatory abuts immediately on Geoffrey Road. The proud owners were probably William John Keylock and his wife. The house was demolished in the 1950s, and 80 to 110 Geoffrey Road stand on the site.

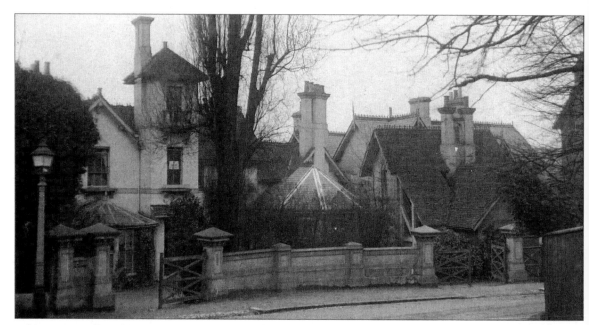

Oak Lawn, 5 The Glebe, was built in the early 1850s, like most of the houses in this exclusive crescent. Its site was the glebe field from which the rector of Lee derived part of his comfortable income, an income further boosted by the ground rents of the new houses. Oak Lawn was greatly altered in the 1950s, on conversion to flats, and the name was changed to Glebe Court.

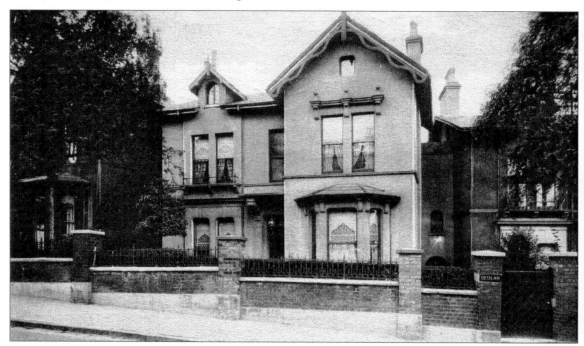

Beulah, 38 Blessington Road, is seen here at the beginning of the First World War, when it was the home of Ernest Arthur Dubois, the Lewis Grove draper. See p. 96 for his shop. Blessington Road was a development of the late 1850s and early 1860s by the Merchant Taylors' Company. Beulah and its neighbours were destroyed by a flying bomb in 1944.

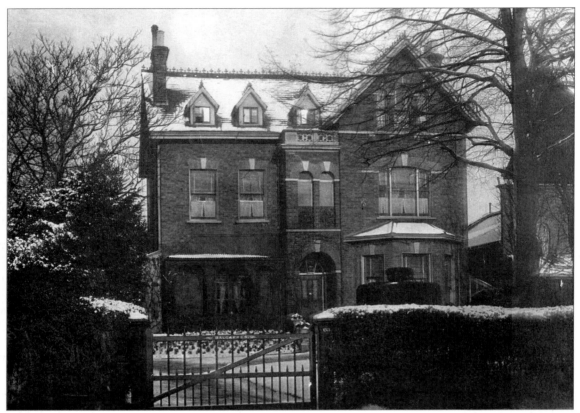

Balcarres, 63 Eltham Road, was built in 1870. It was occupied by James Paton when this photograph was taken in the winter of 1908/9. Balcarres was the second house east of Weigall Road, and thus in the parish of Eltham. It was demolished in the 1970s, and its site used for part of Riverston School.

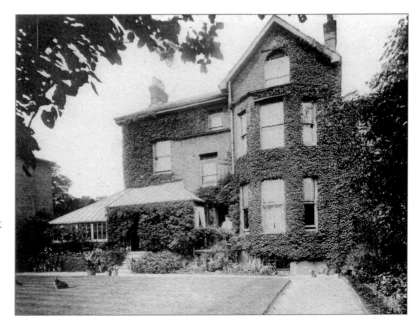

There are more pictures of Buckingham Palace, I suppose, but among houses of its own size and modest pretensions few have been so courted by the camera as 20 Northbrook Road. Most of the photographs show the front. This is a less common glimpse from the sunny, cat-haunted garden. The house, which stood at the corner of Manor Lane Terrace, was built for himself in the late 1860s by Philip East, the developer of Northbrook Road and other parts of the Manor Farm estate. It was demolished just under a century later.

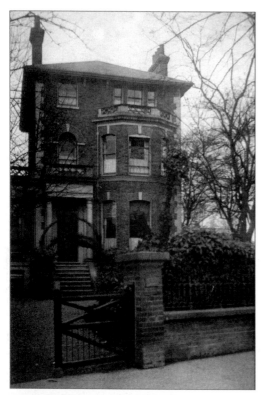

Bloomville, 96 Burnt Ash Road, at the corner of Micheldever Road, has been a doctor's surgery for most of its existence. That is perhaps why it is still standing, one of the few Victorian houses gracing Burnt Ash Road. Bloomville was built in or around 1870. In 1912, when this photograph was probably taken, it was occupied by Dr Raymond Culver Mott.

Below: St Helen's Lodge, 73 Burnt Ash Hill, a house built in 1871, is an unlikely survivor. In the late 1930s Westhorne Avenue carved through this part of Lee like the car of Juggernaut. St Helen's northern neighbours (one of them seen on the left of this picture) were crushed beneath its wheels, but the new highway only scraped the edge of this house, which has prospered remarkably within a few feet of the South Circular. The photograph was taken in 1908, when Mrs Zurhorst was the owner. She is perhaps the lady peering suspiciously from the first-floor window.

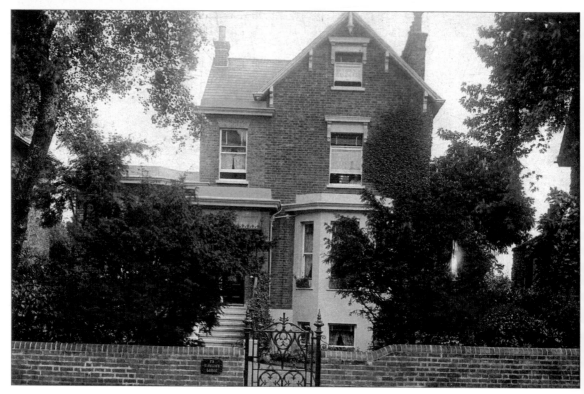

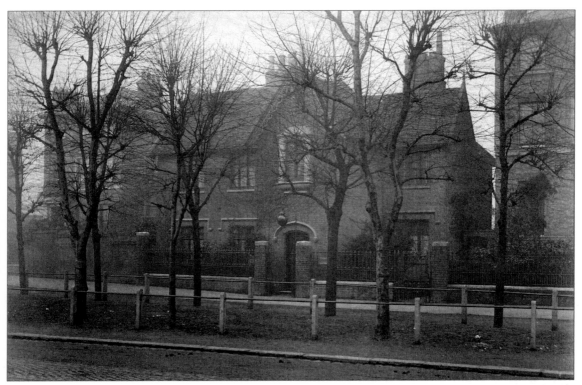

The original Brook House in Lewisham High Street was a timber-framed Tudor building. Early in Queen Victoria's reign the wing seen in this 1880s photograph was added to the south. It inherited the Brook House name in 1858, when the old building was replaced by the villa seen on the right, which was designed by William Walker and known as Oxford House. The similar villa on the left, Clifford House, was built at about the same time. The second Brook House was demolished in the early 1890s. Gregg's bakery and the two shops to the north are now on the site. In the foreground is Allen's Green, for which see p. 21.

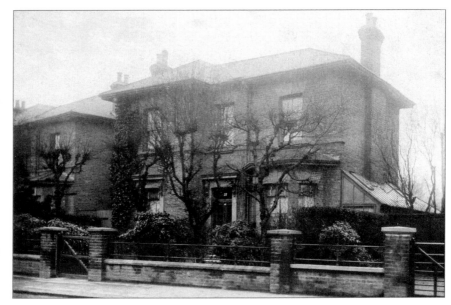

Park Villa, 22 Gilmore Road, a house built in 1871, stood on the south side, between Bonfield and Wisteria Roads. The name perhaps referred to the neighbouring Eastdown Park estate. This photograph was taken in 1913, when Benjamin Miller lived here. Park Villa was demolished in the early 1970s, and replaced by 92 to 98 Gilmore Road.

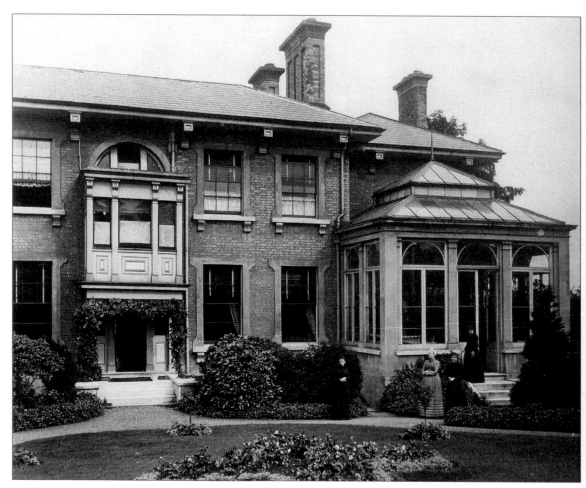

Ravensbourne Park House at Catford was built in 1843 for Robert Main, a Newcastle-born floor-cloth manufacturer who had his works at Great Dover Street in Southwark. I wish I could identify the architect he employed. Ravensbourne Park was a secluded and exclusive development begun in the 1820s, and this was its largest property. It was, in fact, a small country house, surrounded by 16 acres of garden and meadowland. Main did not live to enjoy it for long, and in 1861 his widow let the estate to William Hollebone, a West End wine merchant. He also died within the decade, but his widow Margaret not only stayed on at Ravensbourne Park House, but bought the freehold from the Main family. This photograph of the garden front was taken in 1890, the year of her death, and shows the ladies of the family in mourning. A series of valedictory photographs was taken, as the house was about to be auctioned, but it was not until 1904 that the Hollebone sons could find a buyer. By then the age of country houses in Catford had long gone by, but luckily most of the garden was saved from the builder when the governors of St Dunstan's College acquired it to extend the school playing fields. Polsted Road was built across the site of the house itself. The first plan was to call it Main Road, an idea that was not surprisingly abandoned, but why did nobody think of Hollebone Road?

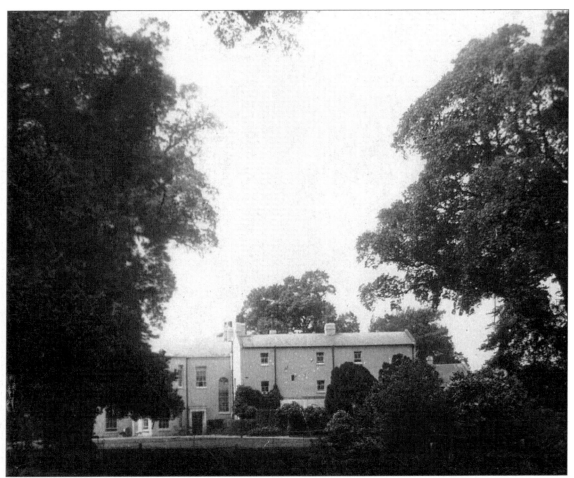

This is an Edwardian view of The Park, Southend, formerly the manor house of Bellingham. The old house on the site was owned in the early eighteenth century by Thomas Inwin, from whom it was inherited by his daughter, Lady Falkland. Her estates passed to Francis Motley Austen (a cousin of Jane Austen) who in 1793 let Bellingham for three lives to Robert Saunders, a nabob. Saunders soon rebuilt the house as seen here, and members of his family continued to occupy it on and off until the 1850s. The three lives expired, possession reverted to Samuel Forster, whose father had acquired the Austen estates at Southend. He let the house to Charles Welborne Slee, a Southwark warehouseman. Samuel Phillips's photograph was taken from the extensive garden, the park from which the house derived its name, shortly before the First World War. The house was then let to Thomas Guntrip, a bookmaker, who ran it as a residential hotel. A flying bomb wrecked The Park in 1944, and the ruins were cleared in November 1945. The Falkland House flats now cover the site of the house. Even before the war Conisborough Crescent, planned in 1936, had nibbled at the garden. After the bombing it was extended to cover the rest.

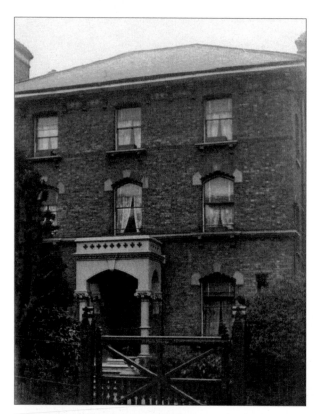

Clyde Villa, 57 (now 195) Honor Oak Road was built in 1867–8. It served as the Vicarage of St Paul's, Waldenshaw Road, from 1912 to 1920. This postcard was sent in 1915 by the wife of the Revd William Francis Shillito.

Below: Rocklands, Horniman Drive, seen here in 1910, was one of four identical villas, built in the late 1850s or early 1860s, that enjoyed the wide views over London from the ridge of this commanding hill. Before boundary and street naming changes the four were in Westwood Park, Camberwell. Rocklands was the southernmost of the houses, and stood next to the entrance to Horniman Gardens, which can be seen on the left. It survived until 1978, when it was demolished to extend Amroth Close.

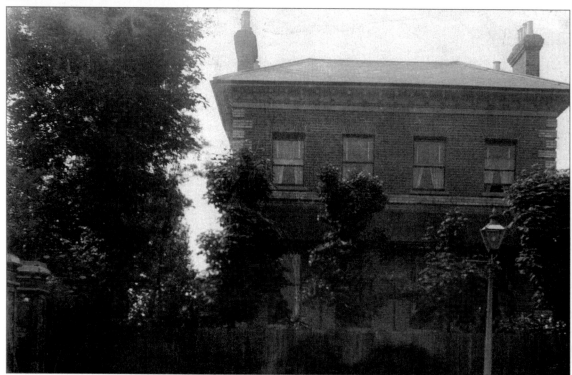

3

Denominations

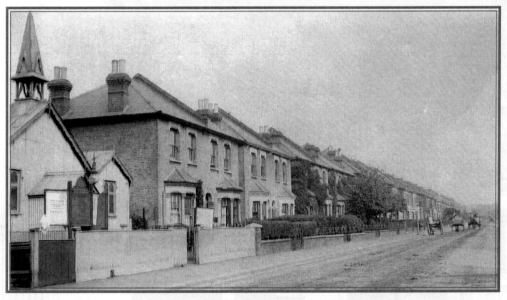

The iron and timber chapel on the left of this Edwardian photograph was built on the
north side of Brownhill Road, opposite Plassy Road, in 1896. It was used at first by a
Methodist Free Church congregation, but was acquired by the Salvation Army in 1909.
The present citadel replaced it in 1925.

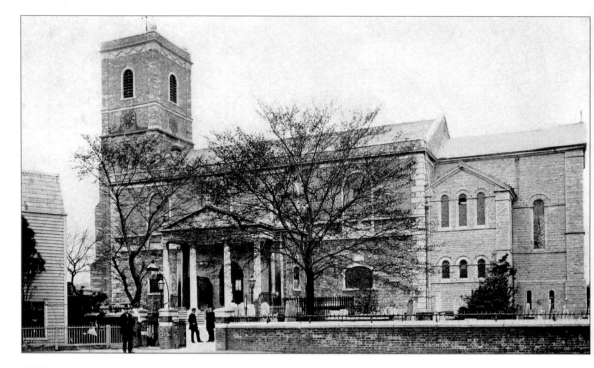

Above: Although this view of St Mary's, the parish church of Lewisham, was issued as a postcard early in the twentieth century, it is clear from the costumes and the rawness of the stone that the photograph was taken not long after Sir Arthur Blomfield's new chancel was completed in 1882. On the left is part of the timber-framed Church House, an old farm that was demolished in 1907.

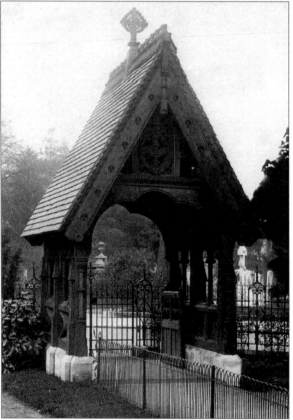

The lych gate of St Margaret's, Lee, which has adorned the comparatively little-seen Church Terrace entrance since 1957, was still in its original prominent position at the corner of Lee Terrace and Brandram Road when this postcard was sent in 1906. The view is across Lee Terrace to the old churchyard. The lych gate was built in 1882 as a memorial to Lady Adelaide Law, wife of the Rector, Frederick Law.

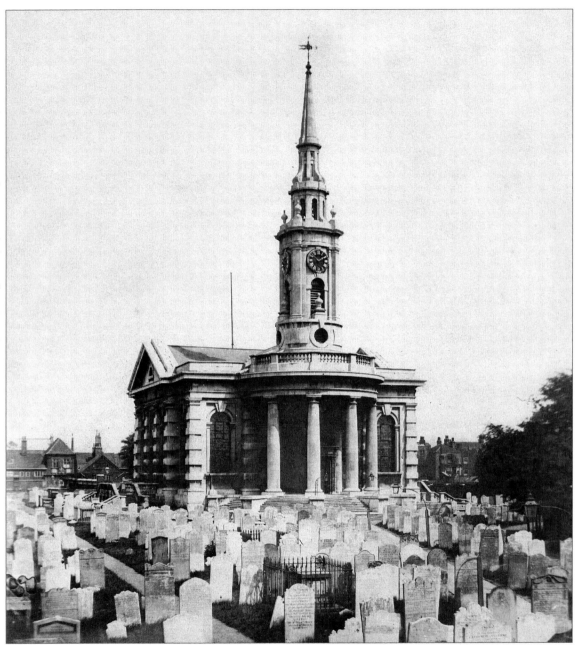

St Paul's Church at Deptford was designed by Thomas Archer and built between 1713 and 1730. It has survived with little external change despite the ravages of war and fire, but its surroundings today could scarely be more different from those seen here in the early 1860s. The most obvious alteration is that the church was then encircled by a graveyard, not a bedraggled lawn. Of lost buildings the most notable are the Trinity Almshouses in Church Street, seen on the left of the picture. They were built in 1670, on a larger scale than Morden College at Blackheath, but demolished in 1877.

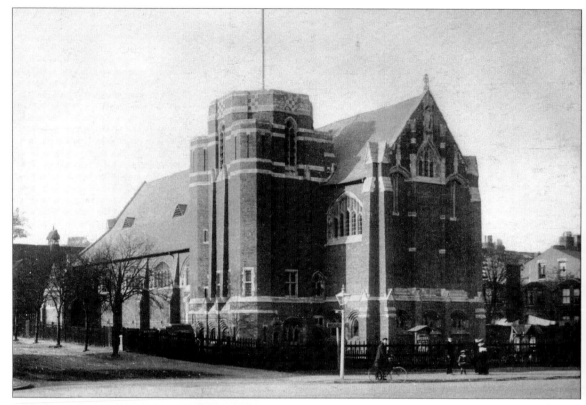

St Hilda's Church in Stondon Park, built in 1907, is seen here when new. It was intended to serve the district of Crofton Park, which had grown rapidly from next to nothing after the station was opened in 1892. St Hilda's was designed by the prolific church specialists Greenaway and Newberry in what has been called 'their rather irresponsible Arts and Crafts Gothic'. The tower, like many another, was to be completed 'when funds are available'.

The Revd Charles H. Grundy was Vicar of St Peter's, Wickham Road, Brockley, from 1887 until 1914. This unusually long tenure might have lasted much longer had he not been killed in a traffic accident while cycling over the dangerous Brockley Cross junction.

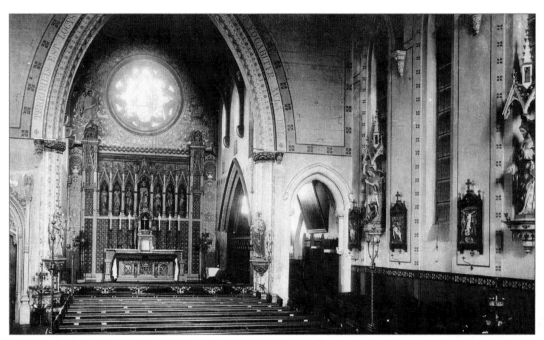

The poor congregation of mainly Irish Roman Catholics that was drawn together in Deptford during the early 1840s could not afford to build a church. Luckily Greenwich had a wealthy parish priest, Canon Richard North, who not only bore most of the cost but designed the building too. The nave of the Church of the Assumption in the High Street was built between 1844 and 1846, the chancel and Lady Chapel in 1859.

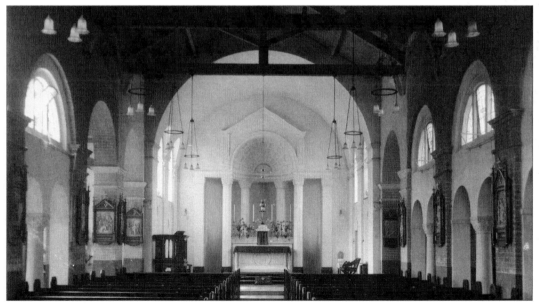

The original part of St William of York, the Roman Catholic church in Brockley Park, Forest Hill, was built in 1905. It was then a modest mission chapel, but after the parish became independent the building was greatly extended in 1930, and there were further additions in the 1980s. This photograph was probably taken shortly after the 1930 works were completed.

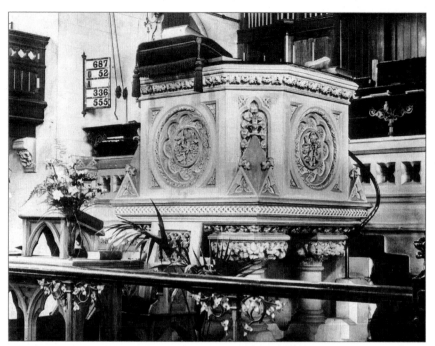

The Lewisham Congregational Church was founded on the west side of the High Street, but moved across to the corner of Courthill Road in 1866. As this Edwardian study of the ornate pulpit suggests, it was a large and wealthy church in its earlier days, but it suffered its full share of Lewisham's twentieth-century blues. All but the tower and spire of the church have been demolished, and the Lewisham United Reformed Church, as it is now called, meets in the former hall in Courthill Road.

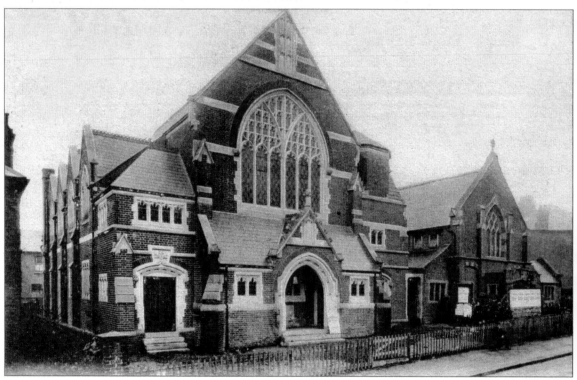

The Hither Green Congregational Church, Torridon Road, was founded in 1899. The church hall, on the right of this photograph, was opened in 1900, the church itself in 1906. This postcard was probably issued just before the completion of the works, as the notices are still outside the hall. The church was demolished in the 1970s and replaced by the flats known as Athlone Court. The hall survives.

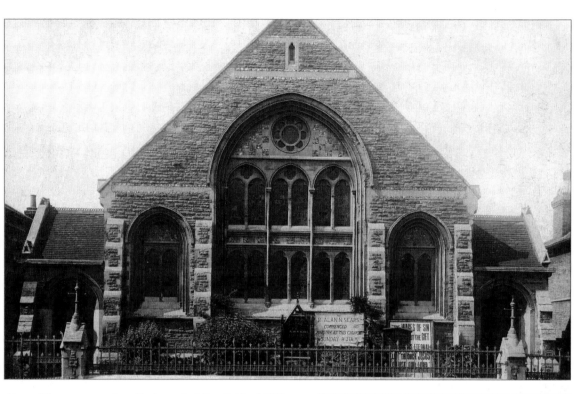

Above: The congregation that created the Catford Hill Baptist Church was formed at the Perry Hill Lecture Hall (later Perry Hill Library and the Kane Memorial Hall) in 1878. The church was built in 1879–80. This photograph was taken in 1927, shortly after the Revd Alan N. Sears had become the pastor, as the notice proclaims. The building, which was renovated, and the interior gutted, a few years ago, is now known as the King's Church.

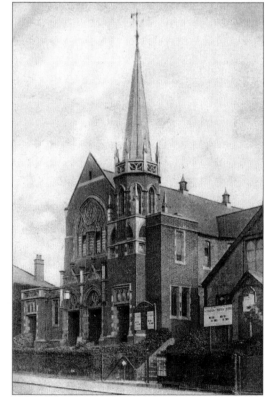

In the 1890s all the denominations rushed to serve the great inflooding population attracted by the Corbett Estate, which was rapidly covering the remaining fields of Catford and Hither Green. In Brownhill Road, its main artery, the Baptists built the tin tabernacle seen on the right of this photograph in 1900, and the permanent church beyond in 1900–3. The church still stands, but the tabernacle was replaced by the War Memorial Buildings in 1925.

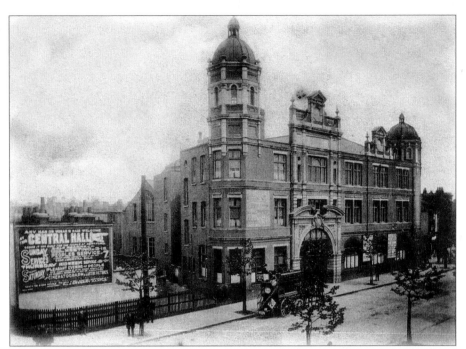

The Deptford
Methodist Mission's
Central Hall in
Creek Road was
built in 1903, and
immediately became
the focus for intense
social work and
evangelism in this
very poor district.
The church was
destroyed by
bombing in 1940,
but the work was
continued from the
lecture hall at the
rear until rebuilding
was possible in
1956.

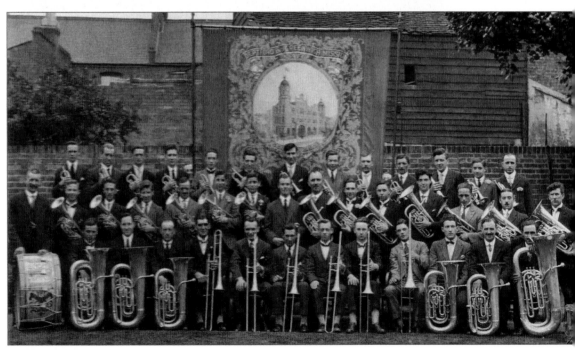

Music played an important part in the work of the Central Hall. The services were supported by a huge choir, an orchestra and a specialist director of music. The cost of instruments delayed the formation of the silver band until 1914, just in time for the ranks to be dreadfully thinned by the First World War, but the band was back to full strength when this photograph was taken in 1924. Its role was to march 'through the poorer quarters of Deptford playing tunes that bring back to many the memory of their childhood's days. The people simply swarm into the streets as the band marches past.'

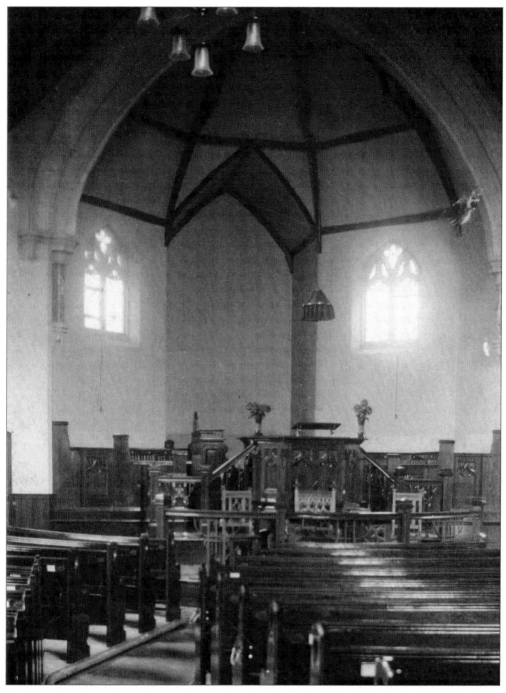

Torridon Road was the great centre of church life on the Corbett Estate. In 1898 the Bible Christian branch of the Methodists established itself in a tent on this site opposite Arngask Road. A church hall was built in 1900, and the large Benson Memorial Church next door in 1913. This photograph of its interior was taken soon afterwards. The church was demolished in 1995, and has been replaced by housing, but services continue in the more modest and economical hall.

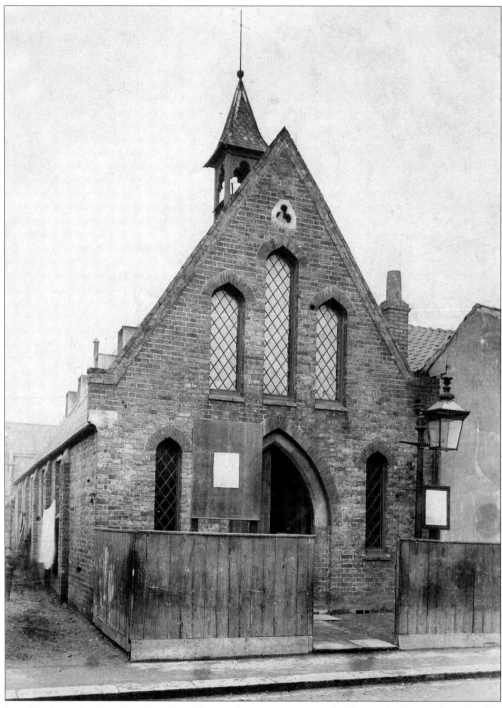

The London City Mission chapel on the north side of Willow Walk, Catford, seen here in the 1890s, was built in 1866. It remained in religious use until the late 1920s, when it became a warehouse. The building was damaged by bombing in 1941 and demolished soon after the war. By then Willow Walk had become Milford Road, and that in turn has been transformed into the Rushey Green entrance to the Catford Shopping Centre.

4

Education

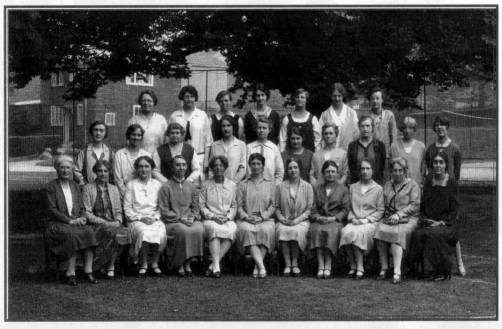

'Not a calf in a carload!' was the comment of Ginger Rogers in one of her films, when faced with a line-up of aspiring chorus girls. If she had seen this group portrait she might have been moved to say, 'Not a face in a field full!' The ladies were the staff of Sydenham County Secondary School (now plain Sydenham School) and the year was 1926. The school had been established in Dartmouth Road since 1917, and had already acquired a fine academic reputation. The caretaker's house in the background, by Cheseman Street, was removed when the extension was built here in 1957.

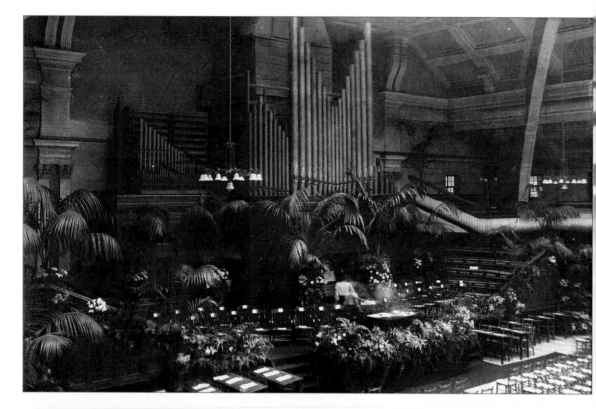

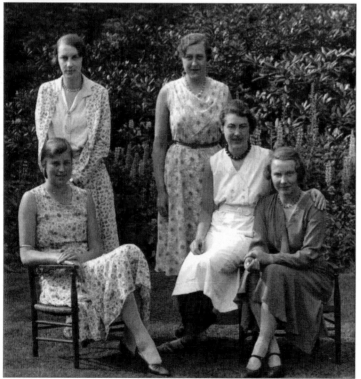

Above: This postcard shows part of the Great Hall at Goldsmiths' College, with the organ in action. It was sent in 1906, with a timeless message for a nervous new student. 'You will feel lonely at first, I know, like many of our girls did, but you will soon find some friends. By the time your two years are up, or before, you will be sorry to leave.'

These confident trainee teachers, who had evidently found some friends, were the prefects at the Goldsmiths' College Pentland House hostel in Old Road, Lee, during the 1931–2 academic year. Their names are noted in a confusing way on the back of the photograph, but the students were (from left to right, I think): 'Beetle' Bates, Mollie Swift, 'Dicky', Marian Bicheno, and Marjory Winch.

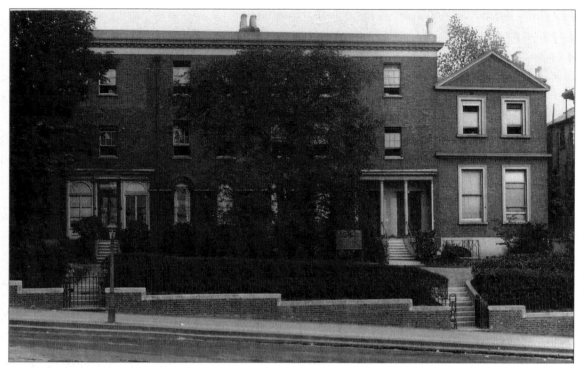

These two photographs of St Christopher's College, Blackheath, were taken in 1912. The one above shows the college buildings at 22 and 23 Montpelier Vale, the one below a group of former students enjoying a reunion in the garden. St Christopher's was a training college for Anglican Sunday School teachers. It was founded in these two fine 1790s houses in 1908 by the Revd William Hume Campbell. His idea proved so popular that in 1916 larger premises were required, and the college moved to Westcombe House, Vanbrugh Park, now the Blackheath High School for Girls.

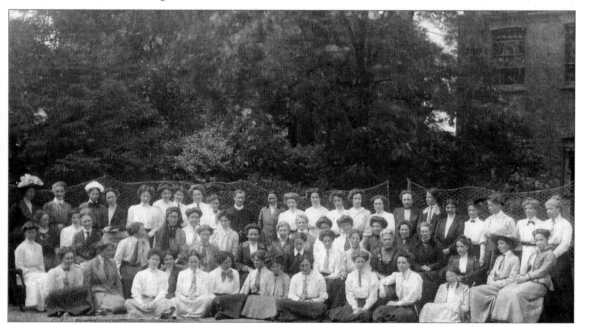

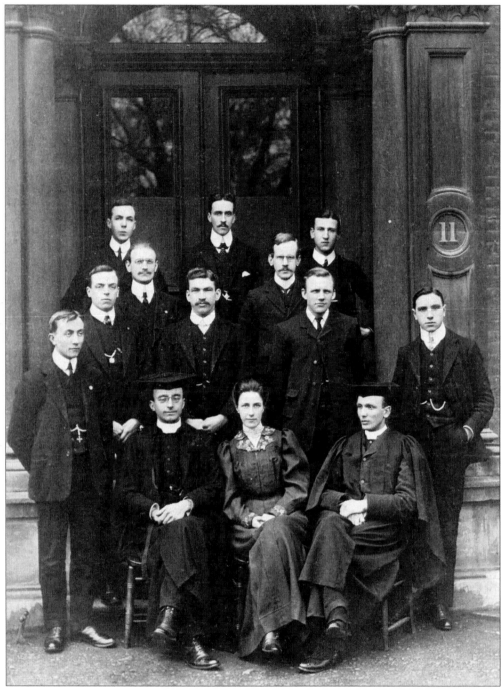

These earnest young men were in training for work in Africa, Asia, Australasia, or wherever else the need might arise, as emissaries of the Church Missionary Society. In the years around 1908, when this photograph was taken, its Preparatory Institution was at 11 and 12 Lansdowne Place, Blackheath, conveniently next to the Green Man. The houses, later 142 and 140 Blackheath Hill, were demolished in 1969. The principal in 1908 was the Revd Charles Edmund Stocks, presumably one of the mortar-boarded gentlemen; the lady was perhaps his wife.

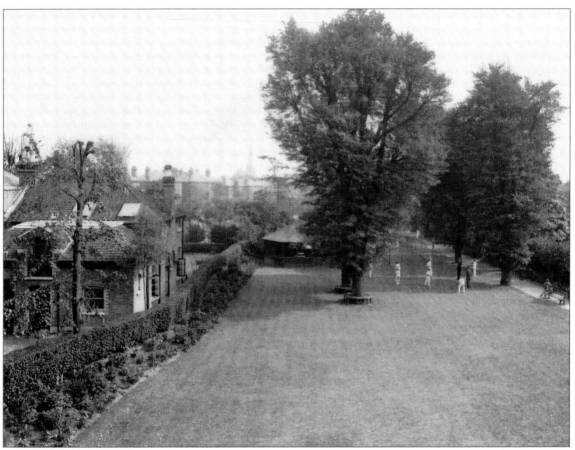

The Belmont House Preparatory School for Boys, which had been long established in Blessington Road, Lee, was moved to 40 Lee Terrace, Blackheath, in 1905 by the Revd Percy Urwick Lasbrey. He and others ran it successfully until 1916, and again from 1922 to 1940. In the interim the house served for several years as a home for soldiers blinded in the First World War. The main business of the Belmont House School was the preparing of boys for Dulwich College, which was well known for its cricket, so it is appropriate that this view of the garden features a session at the nets. The photograph was taken from an upper window of the house in the early days at Lee Terrace. The extraordinary octagonal building – was it a summerhouse or an open-air classroom? – existed only briefly. The building in the left foreground, behind its protective hedge, was perhaps the headmaster's house. The distant houses were in Lee Park, and the spire belonged to Christ Church, Lee Park, which was destroyed in the Second World War. Belmont House, sadly altered, is now a part of the Blackheath Hospital.

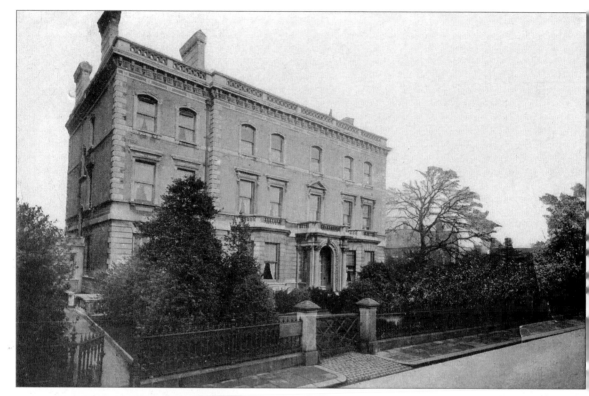

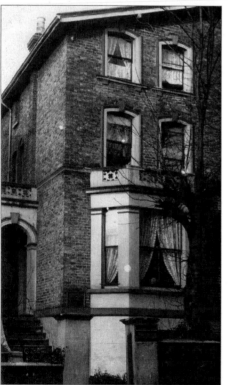

Above: The Misses Wood and Oram were the proprietors of Knightsville College for Girls (and Kindergarten), which occupied the imposing Wyberton House in Lee Terrace from 1906 to 1918. Before that the school had been at what is now the Goldsmiths' College Surrey House hall of residence in Lewisham Way. Mr and Mrs Athro Knight had founded it there in the early 1880s. This photograph was taken in 1910 or a little earlier. In 1919 Wyberton House was to become St Joseph's College for Boys.

Small private schools were common all over Lewisham in the nineteenth century. In the poorer areas their numbers dwindled after the Education Act of 1870, but in the wealthy districts they flourished well into the twentieth century. One of the many in Lee was run by Mrs Lavinia Long from 1898 until 1912 at 6 Belgrave Villas, later 5 Glenton Road. It was a preparatory school, principally for girls, but with a 'separate class for boys'. This photograph was taken in 1911.

Until it was rebuilt in 1889 Colfe's Grammar School in Lewisham Hill was a picturesque muddle of various styles and materials, comprising the original 1650s house and additions made in the lax eighteenth century to accommodate boarders. They were not part of Abraham Colfe's plan, but a profitable sideline introduced by the headmasters and tolerated by the trustees. This was the garden side of the old school photographed shortly before its demolition. The site is now covered by flats numbered in Walerand Road.

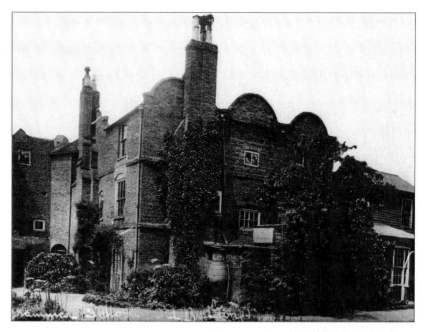

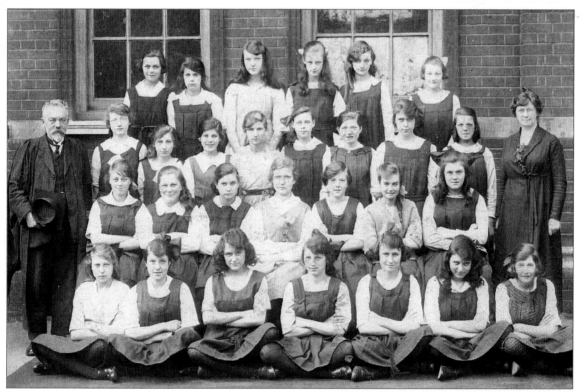

The Addey & Stanhope School in New Cross Road, which was opened in 1899, continues the work of two old Deptford charities, Dean Stanhope's School, which stood in the High Street from 1723 until 1882, and John Addey's in Church Street, which was built in 1821 and survived (latterly converted to industrial use) until the 1970s. This Addey and Stanhope class was posed in the playground in the early 1920s.

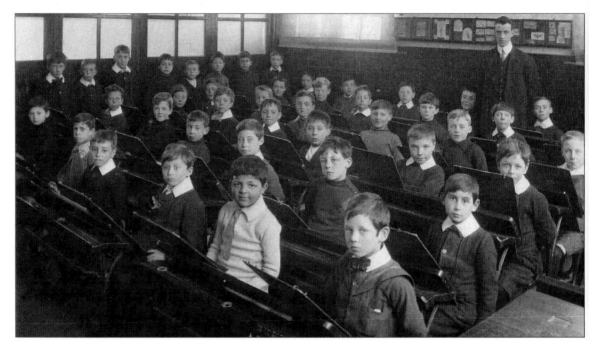

The Hedgely Street Church of England School at Lee, built in 1870 on land given by Lord Northbrook, Lord of the Manor, was renamed the Northbrook School in 1904. According to a contemporary, 'this was formerly a purely agricultural district, and the children were literally running the streets. It required great firmness in order to cure their rough manners.' The savages were fairly tame by the time this class was photographed in 1910.

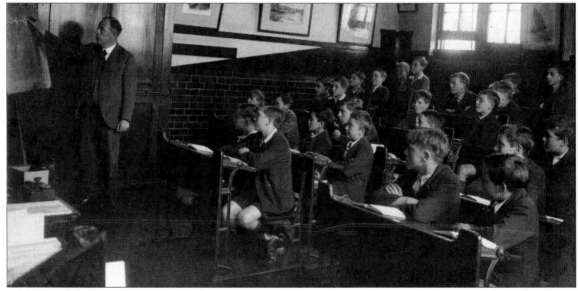

To the boys enduring this mathematical demonstration in 1932 it must have seemed that their lessons and their school were eternal. In their case, neither was true. Grove Street School, Deptford, had been opened in 1893, on a site created by clearing some old houses between Grove Street and Sayes Court Recreation Ground. The building was destroyed by bombing during the Second World War, and the ground was used to enlarge what is now called Sayes Court Gardens.

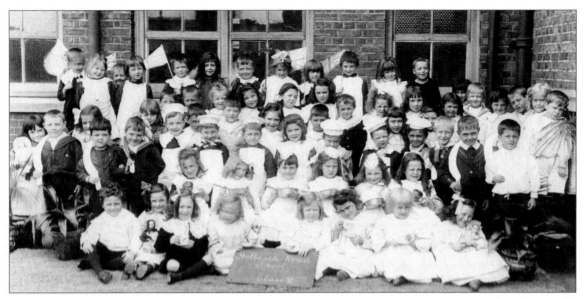

Holbeach Road School in Catford was one of the many that the School Board for London opened in a temporary iron building. The need was pressing, for the local paper soon reported that the new school in The Retreat (the old name for Holbeach Road) 'is not only full, but has 200 applicants whose claims for admission cannot be considered'. The permanent school was built in 1901. This unusually cheerful group of children was photographed in the playground about four years later.

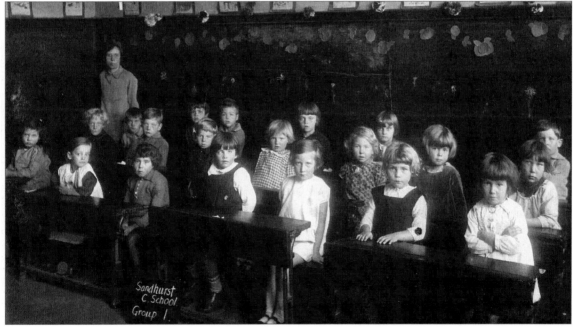

The building of the huge Corbett Estate in Hither Green and Catford between 1896 and 1914 put a huge strain on the already overstretched education system of Lewisham. The crisis was tackled by the use of temporary iron buildings, one of which became Sandhurst School in 1899. The school called 'permanent' replaced it in 1904, but it was largely destroyed in the notorious air raid in 1943 that claimed the lives of so many children. By that time this 1920s class had passed safely into the outer world.

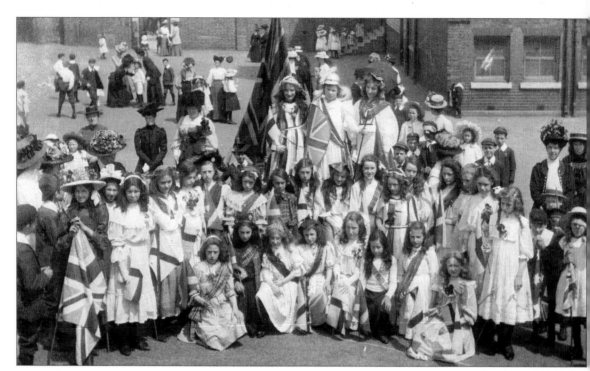

Empire Day, 24 May, was one of the great festivals of the school calendar until empire went out of fashion. There would be processions, inspirational speeches from the headteacher or a local dignitary, special history lessons, fancy dress parades, and the singing of patriotic songs. This was the 1909 celebration at Ennersdale School, Hither Green, which had been opened in 1895, and provided with permanent buildings in 1897–8. This sounds like inspired timing by the School Board for London, as it meant that Ennersdale was ready just in time to cope with the great increase in the local population that followed the opening of Hither Green station in 1895. In fact, the site had been acquired in the 1880s, and building work was only delayed by objections from the headmaster of Hither Green School, who feared that his roll would be depleted. If it did nothing else, Empire Day must have helped the Ennersdale girls to hold their own in the rough and tumble of the playground by providing them with helmets and tridents.

5

Fresh Air

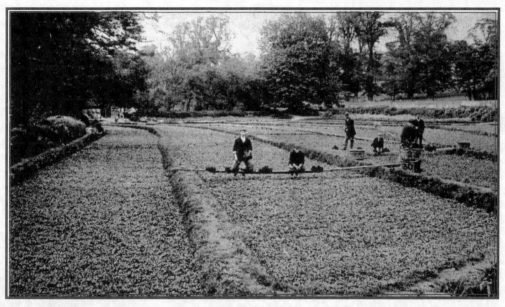

Like all the watermills on the Ravensbourne, the Upper Mill at Southend Village
was made unprofitable in the 1870s by the rise of the great steam mills. The late introduction
of auxiliary power did little to help. A former shepherd named Jacob Perry went to live
at the empty mill house in 1882, as manager of the Forster home farm, and took a lease
in 1892. He converted the mill pond into watercress beds, as seen here in 1906.
Bamford and Chelford Roads are now built across this site.

Bridge House Farm in Ladywell Road, seen here in the late 1850s, provided part of the revenue used by the City of London to maintain London Bridge. At the end of the nineteenth century the land became more valuable for building than farming. The house was demolished in or around 1899, when Chudleigh Road was laid out across its site.

Below: This 1920s postcard captioned 'White House (Egerton's) Farm' is apt to confuse because the building in the centre was not the farm but the pavilion of the White House Cricket Club. The farm was the distinctly unwhite house on the left. The second name still clung to it, though William Egerton had not been the tenant since the 1840s. The farmhouse stood on the east side of Bromley Road, a little south of Bellingham Road. It was demolished in 1936 or 1937, when Daneswood Avenue was built over the remaining fields.

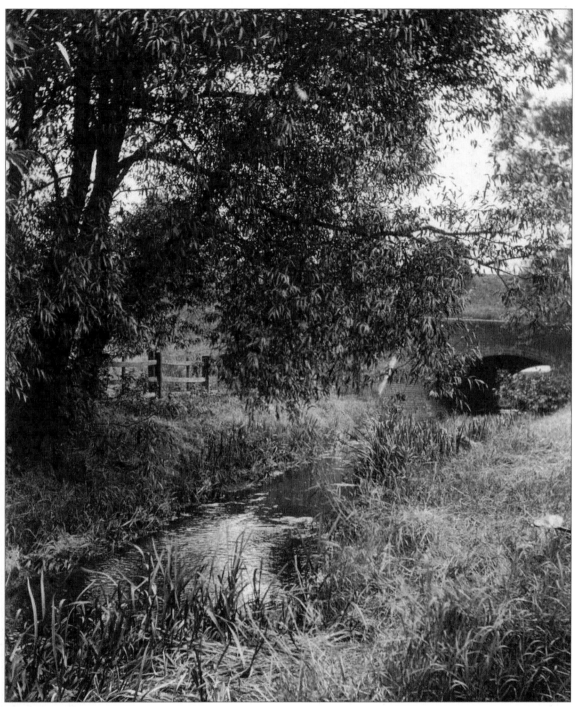

This photograph was taken in the early years of the twentieth century on the stretch of the Pool River that runs behind Exbury Road, Catford, just south of the point where the Pool falls into the Ravensbourne. The bridge was an interesting relic of the once important route from Perry Hill to Bromley Road, of which Elm Lane is now the only part remaining. The route dwindled in importance during the nineteenth century and was extinguished when the railway from Catford Bridge to Bellingham was built in the 1850s.

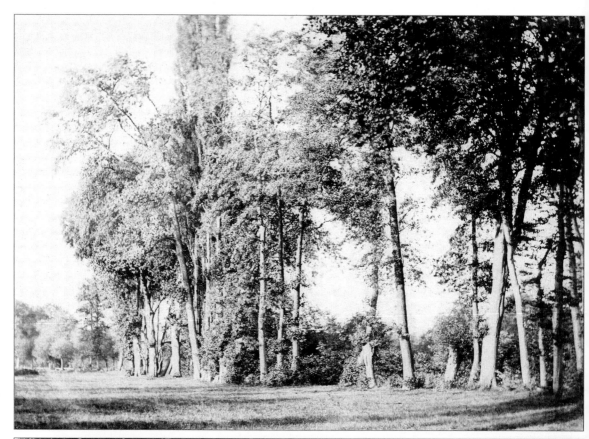

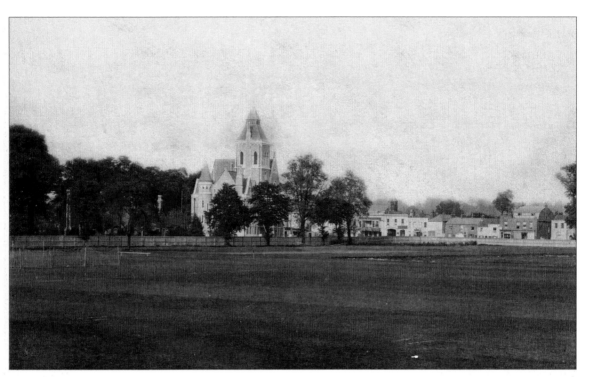

This view from the pavilion of the Private Banks cricket ground at Catford was probably taken in 1875 or soon after, as it shows the offices of the Lewisham Board of Works in pristine condition, and looking more like a fantasy palace of the King of Bavaria than a practical local government headquarters. Soot would soon correct that false impression. The cricket ground was equally new, but the beauty of the setting and the quality of the wicket brought it to early prominence. Kent played the first of many fixtures here, against Hampshire, in June 1875, but it was not until the 1890s that the growth of Catford's population made this a profitable venue for the county. The cricket ground only extended as far as the edge of the mown grass. The rougher ground beyond became the site of Berlin Road (now Canadian Avenue) which was laid out in the late 1870s, and of St Laurence's Church, which was built opposite the Board of Works Offices in 1887. The buildings almost hidden by trees on the left of the picture were the almshouses of the Hatcliffe charity, which stood here from 1857 until 1925. On the right are the eighteenth-century houses and cottages that bordered the east side of Rushey Green to the corner of Sangley Road. All were demolished long ago, and many of the replacements have suffered the same fate. The building with the balcony and archway just to the right of the trees was the old Black Horse, which was to be rebuilt in 1897. It is now known as the Goose on the Green. The house with the mansard roof towards the right edge of the picture was the Crystal Palace beerhouse in the 1850s and '60s, but it had become a private residence again by this time.

Opposite, top: A quiet meadow bordered by trees follows the winding course of a river. It is not a scene readily associated with any part of Lewisham, and certainly not with the High Street. But the photograph was taken between Colfe's almshouses and the Ravensbourne, nearly a century and a half ago. The register office has replaced the almshouses, and extensions to the hospital have covered these fields.

Opposite, bottom: 'The Woods, Verdant Lane' was the name for this well-trodden fragment of rural Lewisham. It was a narrow shaw that bordered the west side of Verdant Lane at its southern end, before it turned sharply to the right and became Whitefoot Lane. This area was covered by the North Downham or Whitefoot Lane extension to the Downham Estate in the late 1930s, and the shaw was felled to widen Verdant Lane between Waters Road and Whitefoot Terrace.

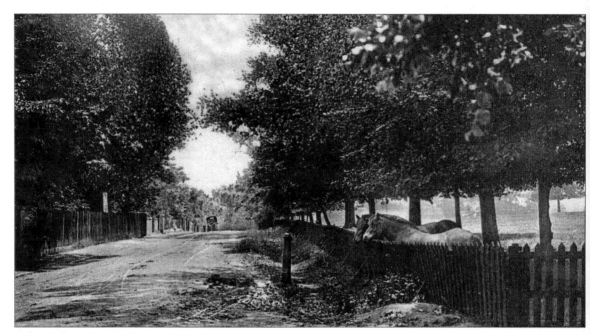

When Ravensbourne Park was created in the 1820s the developers bound themselves to preserve a large proportion of the estate as open ground. The meadow between Ravensbourne Park and Ravensbourne Park Crescent, seen in possession of these horses in 1906, was one of the ornamental enclosures. The area remained a semi-rural backwater until the building of Manwood Road opened up access from the north in 1910.

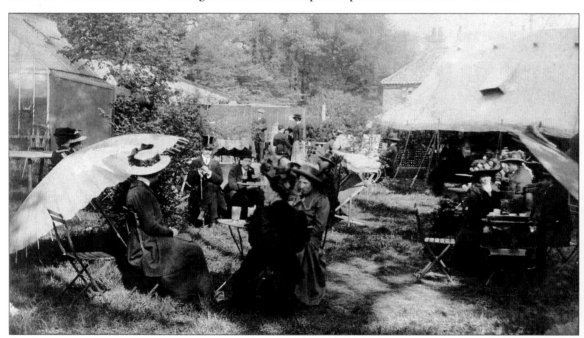

This sun-drenched rural scene from more than a century ago is captioned 'Hazel's Tea Gardens, Southend, Catford'. Edward Hazel lived at 2 Vine Cottages, Bromley Road, until 1902. That was the middle one of three Victorian cottages that stood between Southend Chapel and the Green Man. So if Hazel had set up the marquee in his own garden, this idyllic spot was to become the rather less charming car park of the pub.

The caption is simply 'The Old Tree, Southend'. It was obviously a well-known spot in 1912, but we are left to guess at the exact location. It was probably in what is now Blacklands Road, one of the pair laid out hopefully on either side of Beckenham Hill station, but not immediately seized upon by builders. In that case the road crossing in the middle distance is Southend Lane, with the fields of Bellingham Farm beyond. But was there a bus service to the station along this route?

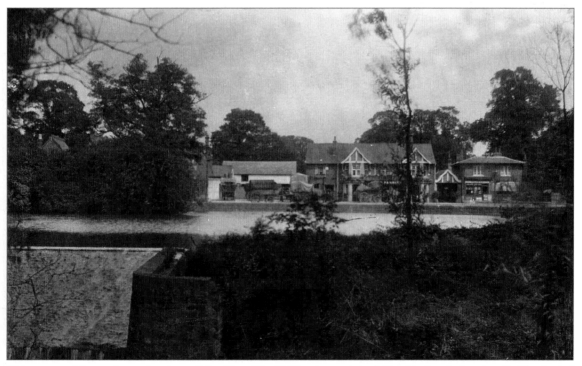

This postcard from about the time of the First World War is captioned 'Duck's Pond, Southend'. The ducks' exclusive possession was short-lived. Until a few years earlier the pond had belonged to the miller at the Lower Mill, and very soon, under the new name of Peter Pan's Pool, it would belong to children, as a popular boating lake. Their parents, meanwhile, would very likely be enjoying their own liquid pleasures in the Green Man, which can be seen beyond the pond.

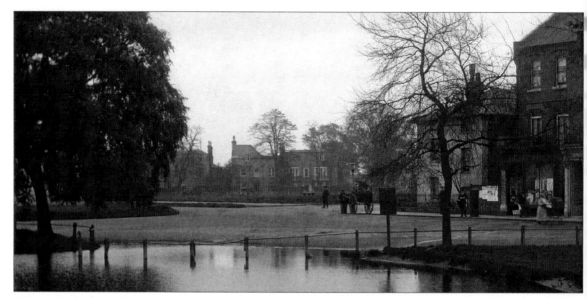

Like most of those on Blackheath, the Hare & Billet Pond probably began as an exhausted gravel pit. When the pub was established early in the eighteenth century – it is just out of view to the right in this 1913 or 1914 photograph – the pond became important as a watering place for the horses of the many carters and coachmen who refreshed themselves in the Hare & Billet. The view here is towards Lloyd's Place.

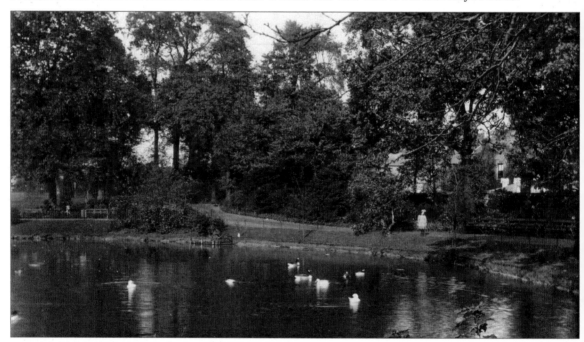

The lake in the Manor House Gardens at Lee was created during the landscaping of the garden in the late eighteenth century, following the rebuilding of the house. It had a practical as well as ornamental purpose. The earth excavated to create the lake was used to heap a mound over the icehouse that had been built to the north, thus keeping it cool, and the ice cut from the frozen lake during the winter was stored in the icehouse for domestic use in the summer. This is the eastern end of the lake a little before the First World War, with Brightfield Road behind.

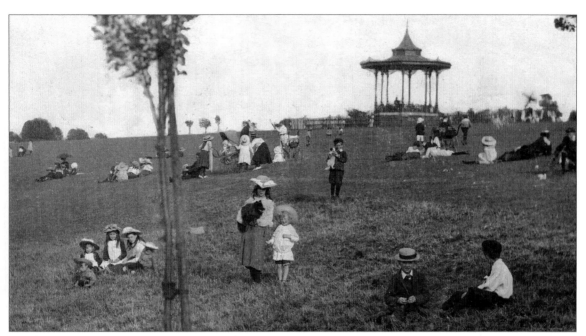

These two scenes on Hilly Fields were captured in 1911 and 1912. The area had long been an unofficial playground for the growing population of Brockley, and when it was threatened with development in the 1880s a vigorous campaign persuaded the local authorities to purchase the land. The park was officially opened by the London County Council in 1896, but it had never ceased to be used while the various improvements were being made. The bandstand, seen above, was already built by 1894. It stood at about the highest point, north of the Brockley County School and south of the cricket ground. The refreshment room, a slightly later addition to the amenities of the park, stood close to Montague Avenue on the path leading from the north-western entrance.

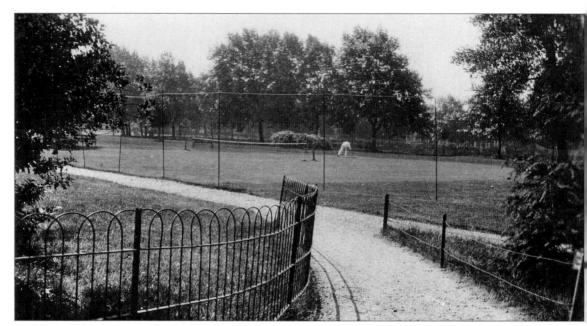

Lewisham Park, the open space enclosed by the road of the same name (see p. 79), was an exclusive amenity for Lord Dartmouth's tenants in the surrounding houses. Apart from using the tennis courts seen in this 1920s view, the proprietors played golf, enjoyed garden parties, and even taught themselves to drive in this private world just off the High Street. It was only in 1964, after the building of the three tower blocks, that the trustees handed over control to the council, and the park was thrown open to the public.

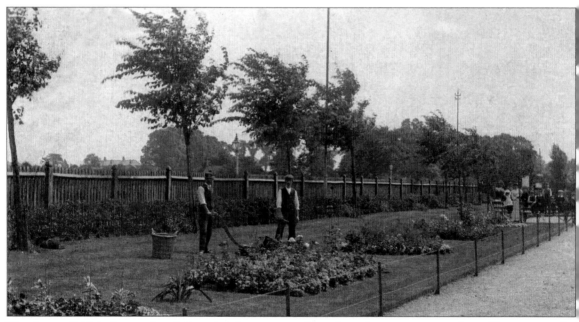

The 9-acre field in Baring Road, Lee, that became Northbrook Park, was given to the public in 1898 by Thomas Baring, 1st Earl of Northbrook, in commemoration of Queen Victoria's Diamond Jubilee. Despite its being a flat and uncomplicated piece of land, it took years to lay out, and was not formally opened until 1903. This photograph was taken four years later.

6

Fun & Games

The Greyhound in Kirkdale is Sydenham's oldest surviving pub. It was established
between 1713 and 1727. The main part of the building, seen here shortly before the
First World War, was an addition of 1873. Part of the older structure survives at
the back. The stables on the right, now demolished, were another fragment
of the old Greyhound.

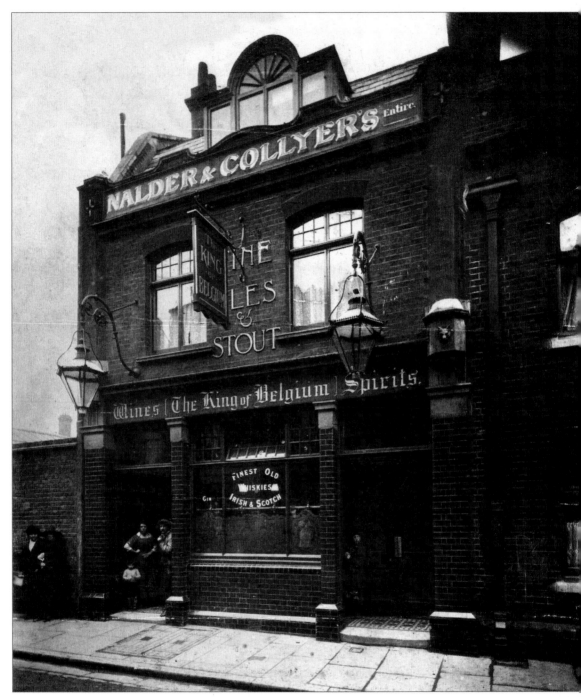

Union Street, Deptford (now known as Albury Street), was built in the early years of the eighteenth century and named after the parliamentary union of England and Scotland in 1707. Thomas Lucas, the builder, was careful to include a pub in his plan, with which to claw back the wages he paid to his workmen. He called it the Swan, but before long it was renamed the King of Prussia in honour of Frederick the Great. During the First World War the compliment was transferred to a new ally, the King of Belgium, as seen here c. 1918. The pub closed about twelve years later.

The Joiners' Arms in Lewisham High Street occupied an eighteenth-century house, but it did not become a pub until 1846, when William Perriam gave up cabinet making for beer selling. This photograph was taken in 1890, when George Edward Pearce was the landlord. The chains in the foreground prevented too many of his customers from tumbling into the Quaggy. The Joiners' Arms, which was rebuilt in 1907, is now known as Dylan's, with a portrait of Bob Dylan as the sign.

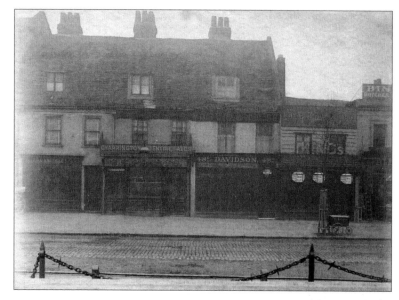

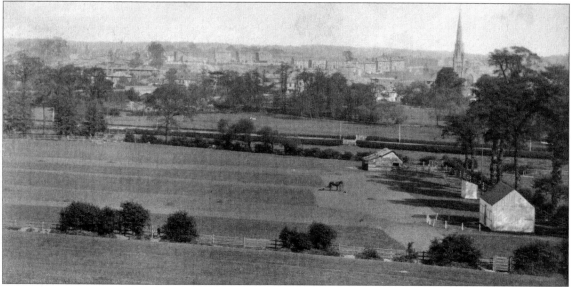

The Lewisham Cricket Ground was established in 1864 on the land north of Ladywell Road and west of the River Ravensbourne now occupied by the southern ends of Algernon Road and Embleton Road. This 1870s view from Hilly Fields shows the greenkeeper's horse enjoying a well-earned break from the task of mowing the grass. This was the more northerly of the two fine pitches used by the Lewisham Cricket Club. The other, which lay beyond the trees to the right, also had its 'permanent' pavilion, as a contemporary guidebook described them. The permanency proved short lived. In the 1880s Samuel Jerrard the builder struck deals with the vicar of Lewisham and the other local landowners, and the cricketers were dismissed after an innings of only twenty years. The nearer buildings beyond the Ravensbourne were in Lewisham High Street. The Congregational Church at the corner of Courthill Road was the most prominent of them. In the distance the new middle-class district east of the High Street can be seen climbing the hill towards Hither Green. The large houses to the left of the Congregational Church spire were the eight detached villas on the east side of Lingards Road, one of them the home of Leland Duncan, the historian of Lewisham. To their left, and rather more distant, were the even larger houses of Clarendon Road, now known as Clarendon Rise.

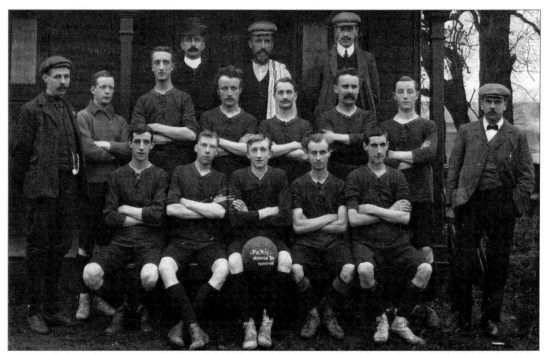

Chiesman Brothers, Lewisham's leading department store, began in 1884 as a draper's shop called the Paris House, and expanded until it occupied the long High Street frontage now taken by the police station. The firm, which eventually numbered Colin Cowdrey among its directors, encouraged the sporting and social interests of its employees. The football team above was the Paris House reserves in the 1907/8 season. Try to imagine these wingers and stoppers in smart business suits saying 'What can I show you today, Madam?' I presume that the outing below was to celebrate the fiftieth anniversary of Chiesman's, in 1934. The charabancs were drawn up in Granville Road. The photograph was taken from a window of the main block, and shows part of the later northern block on the left.

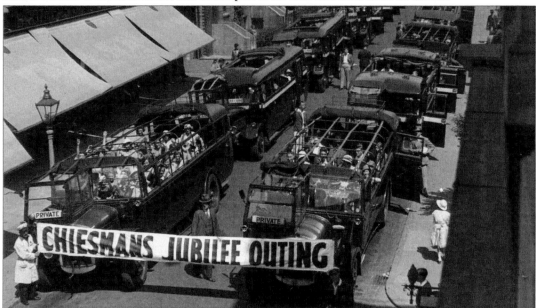

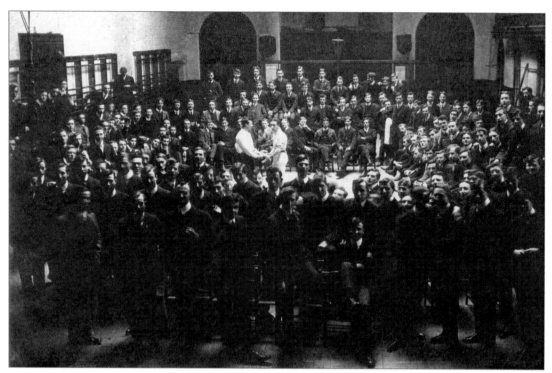

The many photographs that survive to record student life at Goldsmiths' College before the First World War give an impression of boundless exuberance and vitality, reminiscent of a medical school rather than a teacher training college, which Goldsmiths' then largely was. This crowded boxing scene from 1911 has more the atmosphere of a German university than a staid English college. Note the boxer's second in the corner, towel at the ready.

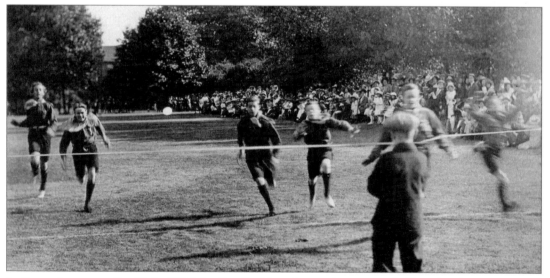

In the ominous month of July 1914 the Deptford Boy Scouts Association held its fourth annual sports day at Sayes Court Gardens. The photograph shows that it was a popular event, untrammelled by any fussy nonsense about singlets or sprinting in lanes. The under-fifteen 100 yards was won by A.H. Collins of the 1st Hatcham troop.

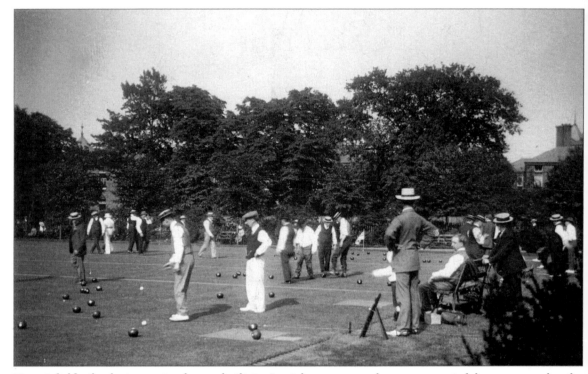

Mountsfield, the last country house built in Lewisham, was only ever occupied by one couple, the entomologist Henry Tibbats Stainton and his wife. When she died the grounds were acquired by the local authority as the nucleus of Mountsfield Park, which was opened in 1903. The house was demolished. The bowling green, seen here in Edwardian high summer, was one of the first amenities provided. It was very popular in the early years, but now seems sadly underused.

The Ravensbourne Club in Eltham Road was the pet scheme of Sir George Pragnell (1863–1916), head of Cook, Son, & Co., drapery warehousemen of St Paul's Churchyard, who built it in 1913–14 as a sporting amenity for his employees. Sir George, who lived at Clovelly, The Avenue (now Somertrees Avenue) in Grove Park, is commemorated by the nearby Pragnell Road.

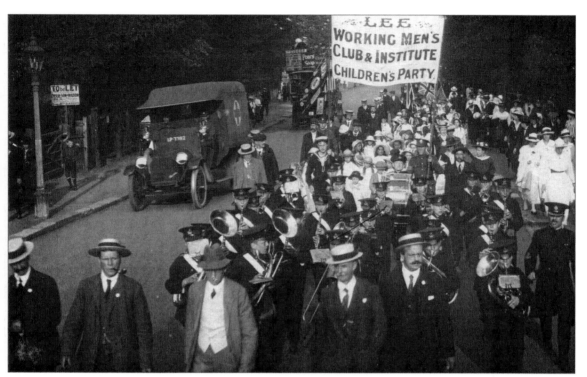

The Lee Working Men's Club acquired its fine premises at 115 Lee Road in 1920, and soon began to make good use of the large garden of the house for parties to suit every age. This 1920s procession along Lee Road shows how keen the club was to extract the maximum publicity value from such events.

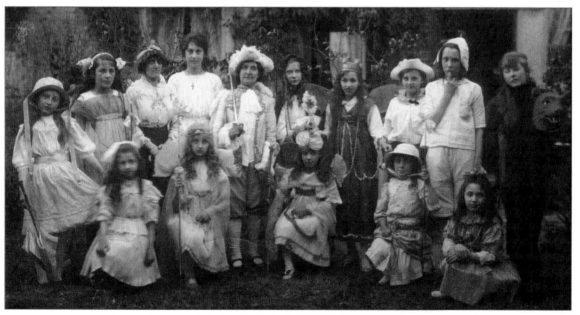

This was the cast of a production of *Red Riding Hood* apparently seen at Sydenham in June 1918. At the time many charity performances were given in aid of the district's war hospitals. The young actresses were photographed by Edgar Humphrey, perhaps in the garden of his studio at Grove Cottage, 34 Sydenham Road.

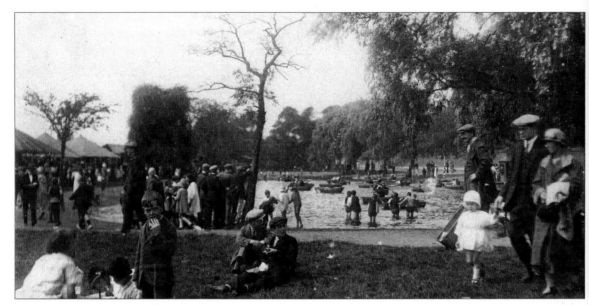

The Bank Holiday funfairs on Blackheath were part of the traditional routine of Victorian London outings, bringing joy to the many and annoyance to the wealthy few, whose normally quiet preserves were invaded and carpeted with litter. By the 1920s, when this postcard was published, the fairs had declined a little from their heyday, but they were still well attended. The scene here is the Folly Pond by the Greenwich Park gates. The booths on the left lined Shooters Hill Road.

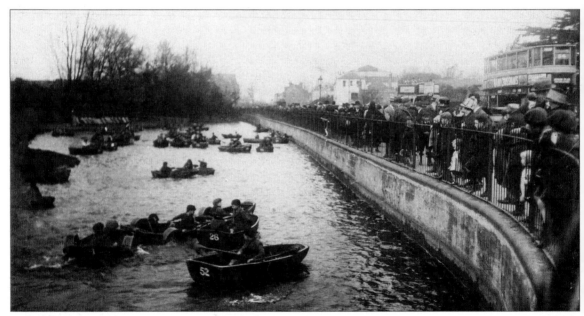

For a few years after the First World War, until it was swamped by building, Southend Village was the country playground on Lewisham's doorstep. The trams, which had penetrated this backwater in 1914, made it easily accessible. At weekends and on bank holidays it would be invaded by crowds of workers in search of fun. In response, the old mill pond of the Lower Mill, disused since 1914, was converted into a children's boating lake known as Peter Pan's Pool. It is seen here from the corner of Beckenham Hill Road in the 1920s.

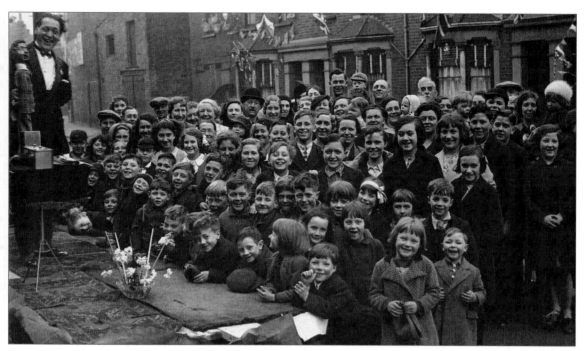

Czar Street in Deptford had previously been known as Workhouse Lane, but this startling social elevation did not change the character of the street, which was always poor. It originally ran north from Prince Street to the gates of Sayes Court, once the temporary home of Peter the Great, and later the St Nicholas workhouse. This ventriloquist had set up his precarious stage in the 1880s southern extension of Czar Street to Evelyn Street. He had come to entertain the children on the occasion of George V's Silver Jubilee in May 1935.

This convivial 1935 Silver Jubilee party, which can surely not have been fuelled purely by milk, was held in Faulkner Street, New Cross, a dull and narrow court of mean houses running between Kender Street and Briant Street. It was built in 1874 and destroyed during the Second World War. None of the houses were rebuilt, but the road still exists after a fashion.

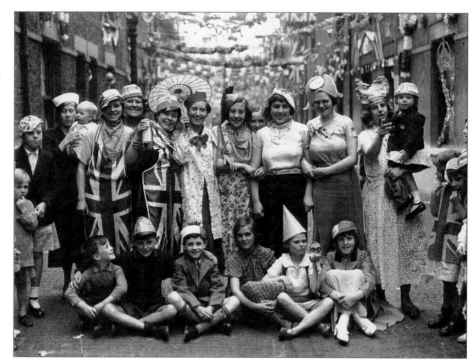

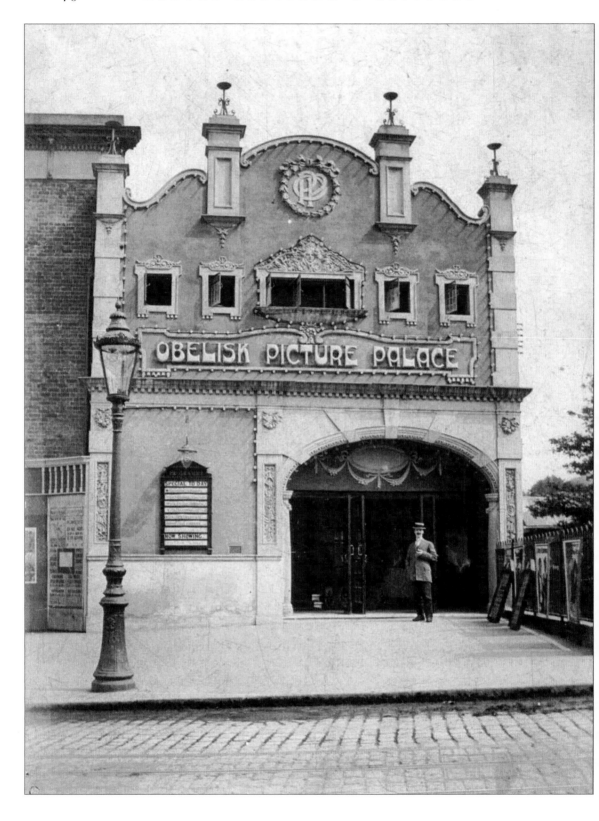

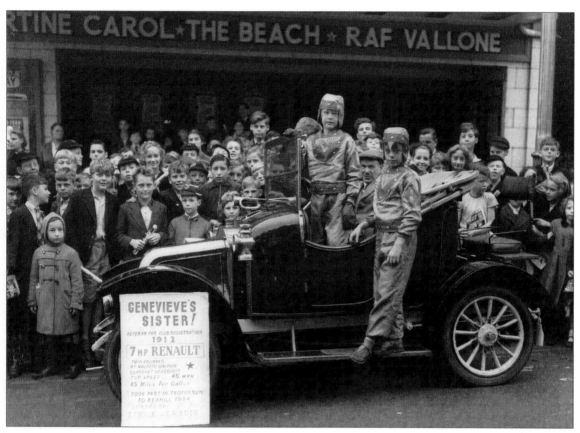

This improbable scene was photographed outside the Granada, Sydenham Road, in July 1956. The 1911 Renault had been used to advertise the previous week's attraction, the London to Brighton comedy *Genevieve*, and was just off to Sevenoaks to fulfil the same function. The spacemen were a live addition to the Saturday morning children's show, which had just ended. (The members of the children's club were known as the Granadiers.) The film for the new week was the 1954 Italian comedy-drama *La Spiaggia*, with Martine Carol, which had been dubbed into English as *The Beach*. The Granada, Sydenham's super-cinema, was beginning to seem as quaint a relic as the Renault. It had been opened in 1931 as the State Cinema, with seating for over a thousand, and was taken over by the Granada chain in 1949. Very soon the new owners began to think they could make more money from the site by demolishing the cinema and building a supermarket. Problems of access prevented the early applications from succeeding, but the inevitable end of Sydenham's last cinema was only delayed until 1971.

Opposite: The Obelisk Picture Palace looks like a smart purpose-built cinema in this picture, which was probably taken in 1912, the year it opened. In fact it was the refronted upper floor of a warehouse that stood next to Lewisham Bridge, on the left bank of the Ravensbourne. It was always a struggling concern, at loggerheads with the licensing authority, and with projection equipment held together by string and hope. Frank Sydney Sinden, the proud proprietor in the straw hat, was not the only man to lose money at the Obelisk, which only remained open until 1923. The Docklands Light Railway station now occupies the site.

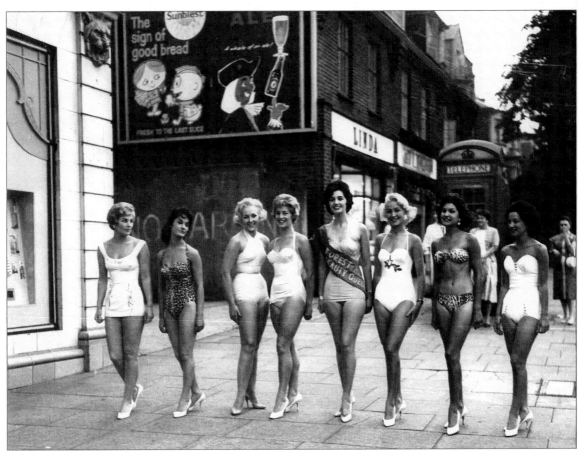

It was the middle of July 1959, but these finalists in the Forest Hill Summer Beauty Queen contest still looked distinctly chilly as they paraded outside the Capitol Cinema in London Road. The management probably found it a profitable contest to stage, as there were heats and semi-finals before the field was winnowed to these favourites; and for the final they had a trump card among the judges: Lewisham's own boxing hero Henry Cooper, then British and Empire Heavyweight Champion. He and his fellow judges, who perhaps shared a height fetish, gave first prize to Jill Hogg of Catford. The runner-up, fourth from the left in this group, was Diana French, a model from Belsize Park. Third prize went to Anne Simmonds of the Father Red Cap, Camberwell Green (third from the right) who must have felt the need for a stiff drink after such an upset. The Capitol, Lewisham's first super-cinema, had opened in February 1929, just two months before it was able to introduce Forest Hill to the wonders of talking pictures. When it closed in 1973 J. Stanley Beard's fine building looked doomed, but bingo kept it going until 1996, by which time appreciation of cinema architecture had increased sufficiently for it to receive the protection of Grade II listing. The Capitol has now been converted into a pub, with most of the original features retained.

7

Byways

Lewisham Park, an exclusive development begun in the 1850s, was completed very slowly.
These five houses on the east side were built in 1878 to the designs of the Lewisham architect
Horace T. Bonner. The two pairs on the right became nos 55 to 58, the large corner house
was Belvedere, no. 59. Another notable Lewisham architect, Albert Lewis Guy, lived at
no. 55, which he called Rostrevor. Belvedere was demolished in the late 1960s, the other
four in the 1970s.

This view of Watergate Street, taken in January 1902, apparently shows part of the watergate itself in the distance; but if so, it must have stood in the Trevithick Street area, a hundred yards from the Thames. It is not shown on maps, but here it is as a solid physical fact. These old houses, formerly home to generations of sailors and shipwrights, together with the Bull and Butcher pub that they frequented, had just been acquired for demolition by the Corporation of London, which was about to enlarge the Foreign Cattle Market. Charles Good's coffee rooms were at the corner of Prince Street.

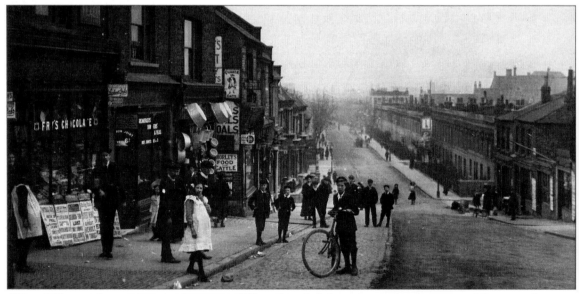

Clifton Hill, now for some reason known as Clifton Rise, led down into a dreary region of Victorian housing that was cleared in the early 1970s to create dreary Fordham Park. This photograph from near the top was perhaps taken in 1919, as the headlines outside the newsagent's shop are all about the Turkish revolution.

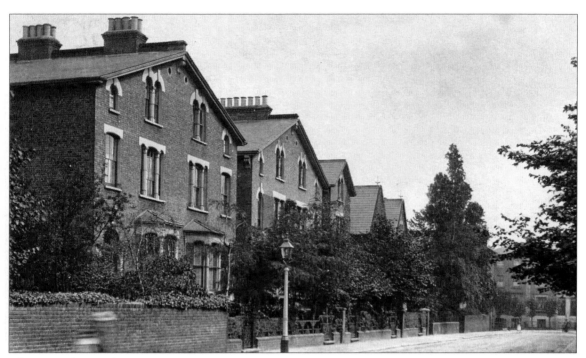

Albert Road, Brockley, which has been known as Darling Road since 1937 in honour of Lord Darling (see p. 108), was created in the late 1860s. The south side was the first to be built, in 1867–8. This photograph shows the north side, nos 2 to 14, in 1905, with nos 35 and 37 Tyrwhitt Road in the distance. Darling Road survives with little change.

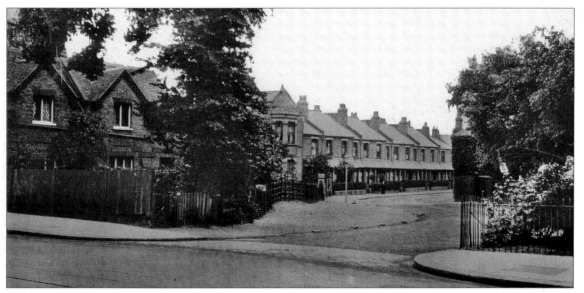

This peep into Brockley Grove from Brockley Road dates from 1914. The houses on the left, known as Joy or St Germans Cottages, were built in about 1860, and replaced by the present shops in 1933. The ivy-clad building on the right was the lodge of Brockley Hall, demolished when that estate was broken up in 1932. The green in the right foreground was later occupied by the public lavatory that has recently undergone an improbable but entirely successful metamorphosis into an estate agent's office.

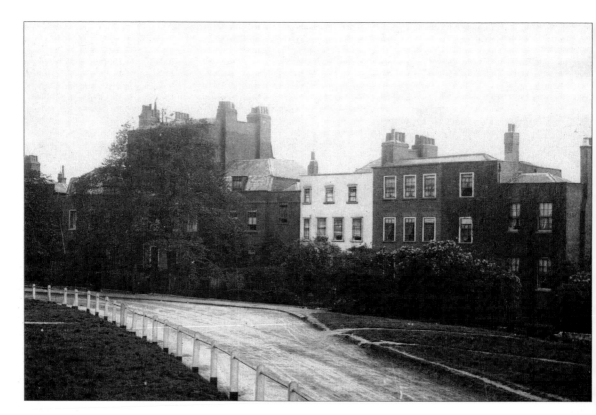

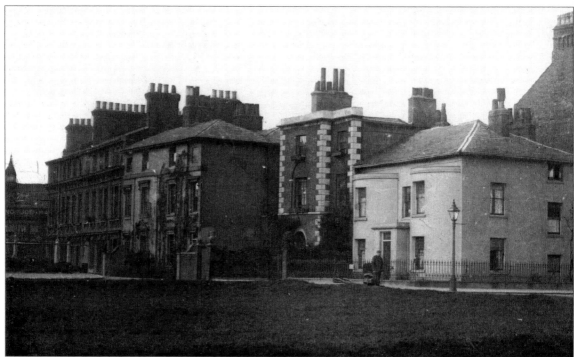

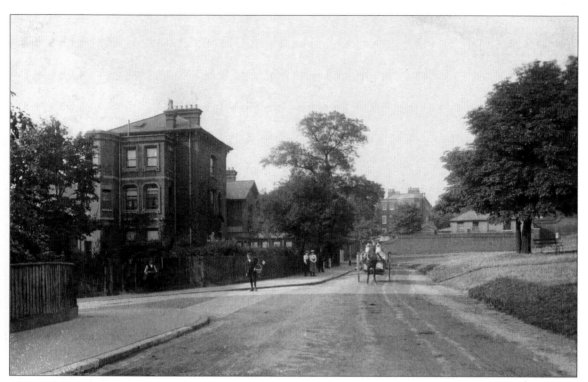

This view up Lewisham Hill towards Dartmouth Row dates from shortly before 1906. On the left is Blackheath Rise, with West Bank, 67 Lewisham Hill, at its corner. Beyond West Bank, and hidden by it, is Cedar Lodge, for which see p. 29. In the distance is Dartmouth House, formerly the residence of the Earls of Dartmouth, Lords of the Manor of Lewisham. From 1893 until 1905 it was occupied by Huyshe Wolcot Yeatman-Biggs, Bishop of Southwark, who had been fortunate enough to marry the fourth earl's daughter. From 1906 it was the College of Greyladies, an Anglican religious order, for which a large dormitory wing was added. The building on the right was part of the Dartmouth House stable. West Bank had been built in 1863 for Samuel Smiles, the very model of a modern didactic biographer, out of the ever-rolling royalties of his best-seller, *Self Help*. In Smiles's day West Bank had been a suitably four-square, regular house, but he had moved to Kensington in 1874, and in 1897 it had been asymmetrically extended for the new owner, Samuel Cutler. West Bank was acquired by St John's Hospital in 1925, but had scarcely settled into its final role as part of the nurses' home before it was seriously bomb-damaged. The ruins were demolished shortly after the war.

Opposite: One of the most attractive features of Blackheath is the informal crescent created by Lloyd's Place, Grote's Buildings and Grote's Place. It was not the result of planning but of piecemeal encroachment on the Heath during the eighteenth century. Grote's Buildings, seen in the top picture *c*. 1920, occupied a field belonging to Morden College that was let to Andrew Grote in the 1760s. The six houses featured here were built under his laissez-faire regime. All still survive. Grote's Place, seen in the bottom picture in 1913, has had a more complicated history. It was part of a 1730s encroachment, of which the main feature was the Hare & Billet pub. The wooden cottages that surrounded it were demolished in the nineteenth century and replaced by the houses seen here. Thomas Tilling, the job master and horse bus proprietor, had the stables on the left from 1893 to 1921.

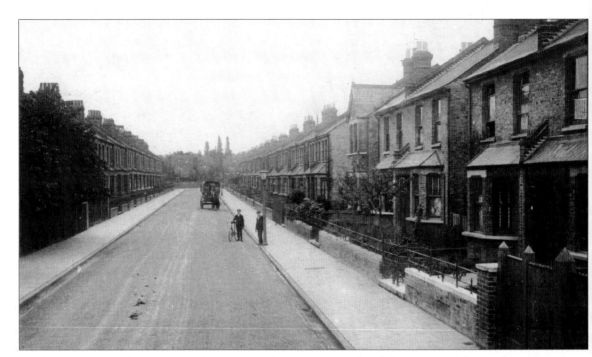

Development of Meadowcourt Road, Lee Green, began in 1893, but did not proceed far until ten years later. It is seen here from the Eltham Road end in 1912. On the right are nos 6, 8, etc. The gabled house, no. 14, was then detached. No. 16 was added to it in the 1960s. Some of the farther houses on the right and the nearer ones on the left were destroyed during the Second World War. The Eurocentre language school now occupies all the foreground on the left.

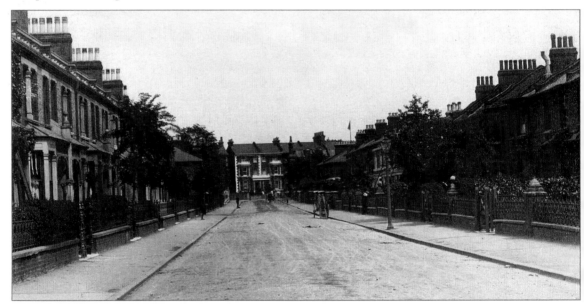

Lampmead Road was called after the ancient field, part of the endowment of Hatcliffe's Charity, on which it was built in the 1870s. The name was an afterthought. The original choice was Lenham Road. When the present Lenham Road was added in the following decade the original part was re-christened Lampmead Road. This Edwardian postcard shows the view towards Lee High Road.

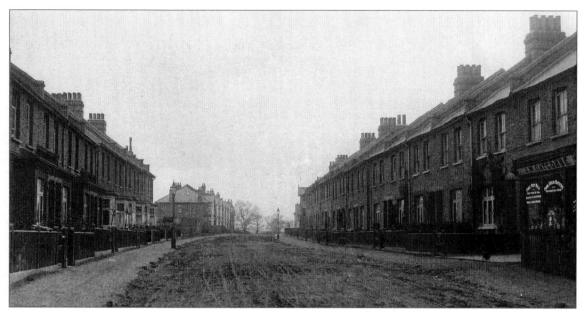

This photograph of Heather Road as seen from Burnt Ash Hill was apparently taken in 1907, as that is the only year in which Joseph Williamson Gatcombe is listed as the proprietor of the Grove Park Dairy, the shop on the right. He also had branches at Blackheath and in Lee High Road. Heather Road had only been laid out in 1901, and six years later there were still vacant building plots.

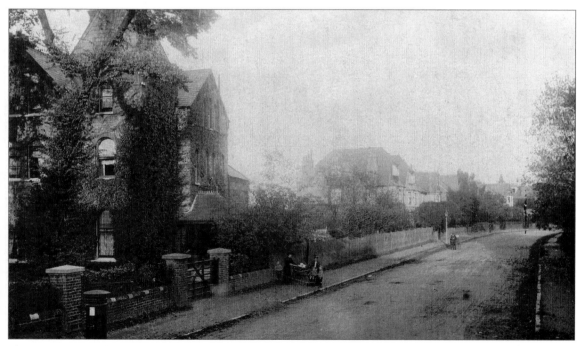

This 1915 postcard is captioned 'Burnt Ash Hill', which caused some confusion at first. In fact it shows Winn Road *from* Burnt Ash Hill. The 1870s and '80s houses in the background were 3, 5 and 7 Winn Road; there was no no. 1. Danescombe was the name for one of the houses, and it was inherited by the development that replaced them all in the late 1970s. Tower House, 137 Burnt Ash Hill (now also demolished), is on the left.

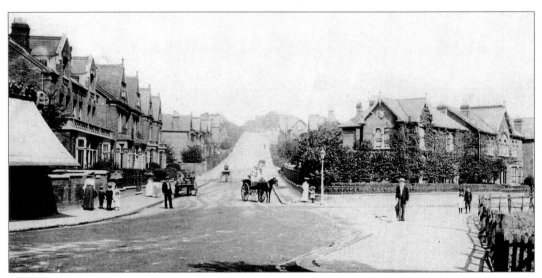

Vicars Hill, Ladywell, so called because the area was glebe land, providing part of the income of the vicars of Lewisham, was a mere footpath until the 1880s. It was then that Samuel Jerrard, the leading Lewisham builder of the period, began to open up the land between Loampit Hill and Ladywell Road. He began work on Vicars Hill in the late 1880s, starting at the southern end. The road was nearing completion when these two postcards were published in 1911–12. The one above, taken from the corner of Mercy Terrace, shows the junction with Algernon Road, which branches to the right. On the left are some of the first houses built in Vicars Hill, in 1889. No. 1, the nearest, was occupied by members of the Jerrard family. The bottom picture was probably taken from an upper window of no. 39. It shows the houses between Ermine Road and Embleton Road, built in the early 1890s. Half of them – all the nearer ones – were destroyed during the Second World War.

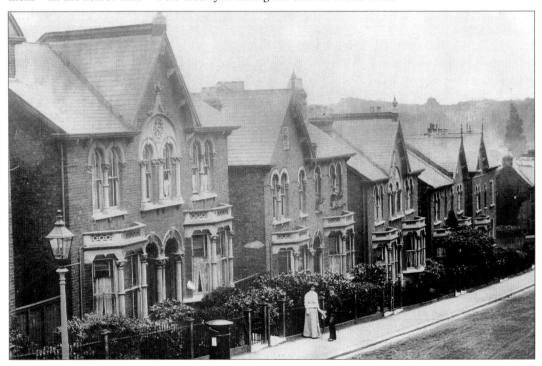

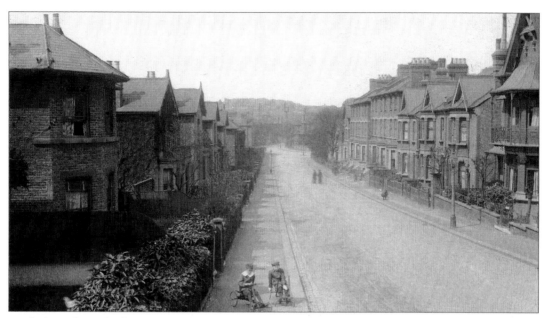

Morley Road was laid out in the 1860s on land belonging to Lord Dartmouth. Most of the houses were built in the 1860s and '70s, but a few plots remained vacant until the twentieth century. This view down the hill from Lingards Road shows nos 23 to 19, the last group to be built, when they were new. They are the three matching Edwardian gabled houses on the right. The tall house with the balcony and veranda on the extreme right is Cottesmore, no. 25, which was built in the late 1880s.

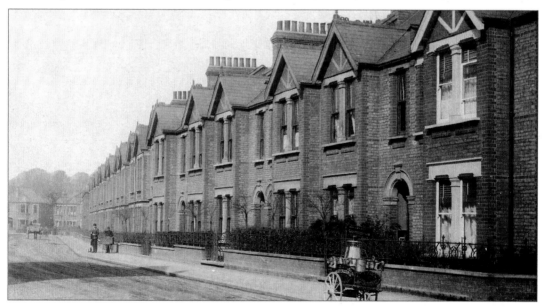

Longhurst Road was a part of the great expansion of Hither Green that followed the opening of the station in 1895. Within a decade all the nearby fields had been covered with respectable houses filled by commercial clerks and other rank and file of the great City army. This was the view north-west from Staplehurst Road in 1905. The owner of the milk cart outside 60 Longhurst Road had a notice on it boasting that his cows were kept at Shroffold's Farm, then the real country a mile or two to the south, now part of the Downham Estate.

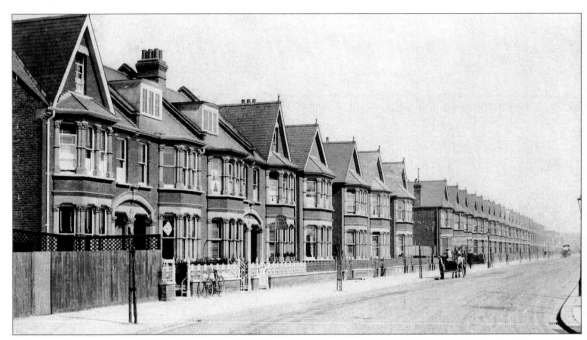

Culverley Road, where building began in 1902, was the first on the Forster family's Sangley Farm estate, which occupied most of the land between Catford and Southend. It was largely built by James Watt, whose 'To be sold or let' sign can be seen in the window of no. 15 in this 1908 photograph. The numbering began at 13 because Sangley Hall, with its large garden, still stood at the corner of Bromley Road. The gap on the left, by the milk cart, was not a side turning, but the plot on which nos 29 and 31 were to be built in 1911.

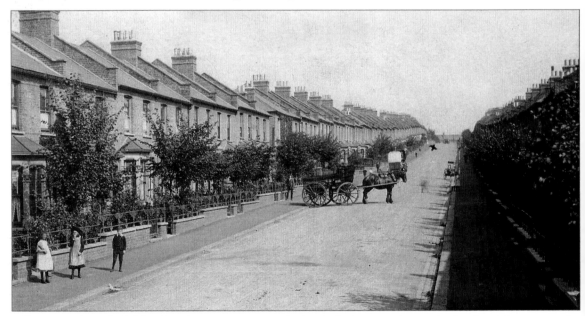

Killearn Road, Catford, like the others on Cameron Corbett's St Germans Estate, had a Scottish name and a monotonous appearance. The houses were built rapidly between 1899 and 1901, all in the same style, and there are no side turnings, so only the slope makes it possible to say that this is the view towards Torridon Road. At least on this sunny Edwardian day tradesmen were adding some variety to the children's lives.

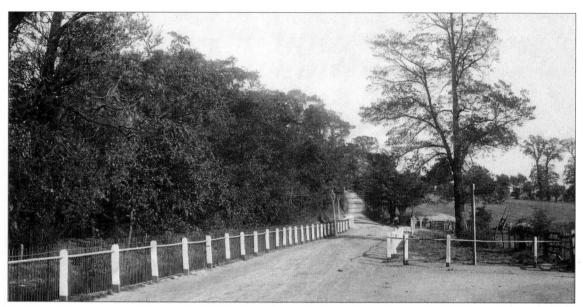

Southend Lane is seen here in the 1890s from beneath the railway bridge near the Sydenham end. It remained a charming country lane until the early 1920s, when the Bellingham Estate covered all the fields to the north, the left in this picture. Development on the south side came in the 1930s, though here at the corner of Worsley Bridge Road nothing was built until after the Second World War. A small part of the open ground on the right survives as Southend Park.

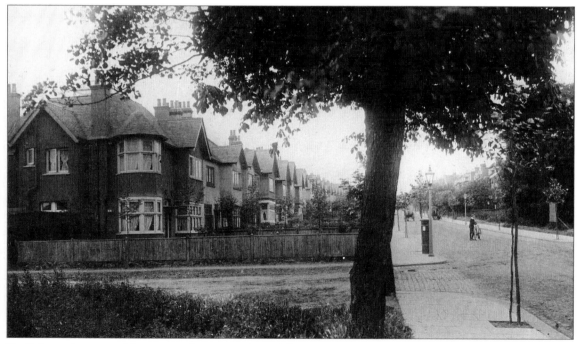

Until the early years of the twentieth century the two big houses at the western end (see p. 27) were the only ones in Chinbrook Road. The semi-detached houses beyond them, stretching nearly to Amblecote Road, were built between 1904 and 1907. This 1912 photograph, taken from just beyond Amblecote Road, shows the view towards Bromley Road. The detached house on the left, no. 54 or Portmadoc, dates from 1907.

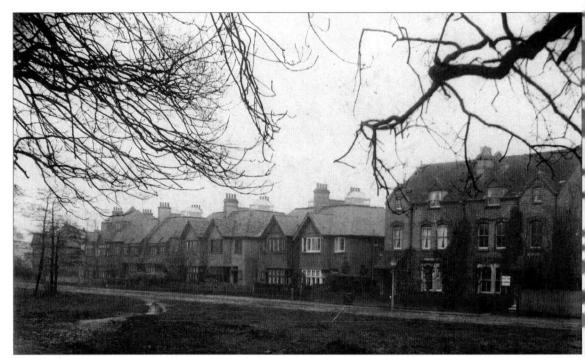

These two views of the same part of Fairfield Road, now known as Luffman Road, were taken just before the First World War and in the early 1930s. The road was laid out in the late 1880s, when nos 39 and 41 were built. The other houses on the east side were Edwardian, or built in the 1920s. There was some bomb damage in the Second World War, but many of the original houses are still standing. The earlier photograph, above, shows nos 41 to 23, as they could then be seen from Chinbrook Road. By the early 1930s the field in the foreground had been covered by the houses (nos 44, 42, etc.) shown on the left of the bottom picture. They were built in and around 1925. The houses on the right of this photo were nos 37 to 31.

8

Trade & Industry

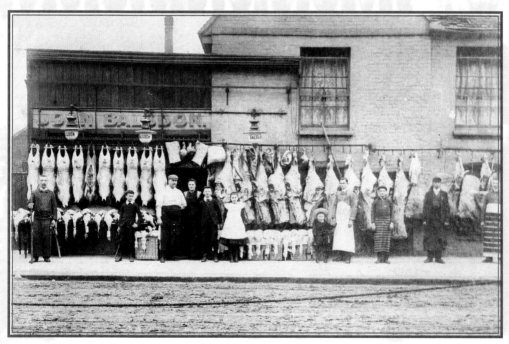

John Balsdon opened his butcher's shop at 245 Lewisham High Street in 1889.
It was renumbered 291 in 1905, five years before this photograph was taken.
The main part of his premises, the seventeenth-century house on the right, was destroyed
during the Second World War, but the business continued in the shack on the left until
the ground was required for the forecourt of the Ladywell Leisure Centre in the
early 1960s. The Balsdons then moved to 5 George Lane.

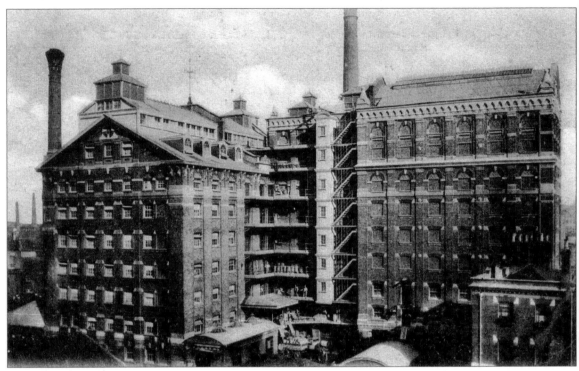

The brothers Joseph and Henry Robinson took over the Lewisham Bridge watermill in 1851. Within twenty years there was so much demand for their flour that they decided to build a steam-powered mill on a new site at Deptford Bridge, to be worked in tandem with Lewisham. This postcard shows the Deptford Bridge Mill in 1905. It stood on the east bank of the Ravensbourne, just north of the bridge, until destroyed by fire in 1970. See p. 132.

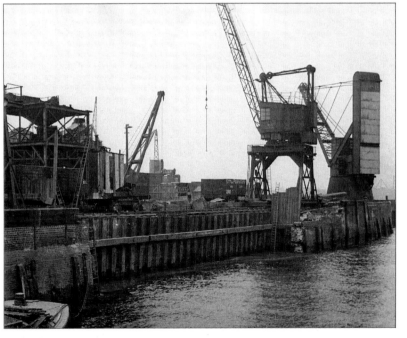

The Deptford Wharf Branch Railway was planned in 1846 to give the London and Croydon Company access to the Thames and its goods traffic. It was opened in 1849. The company leased Dudman's Dock at Deptford as its wharf. For more than a century huge quantities of coal, timber and stone were landed here for distribution all the way to the south coast. The wharf naturally became a target during the Second World War. This was some of the damage suffered in 1941. Deptford Wharf closed in the early 1970s, and housing now covers the site.

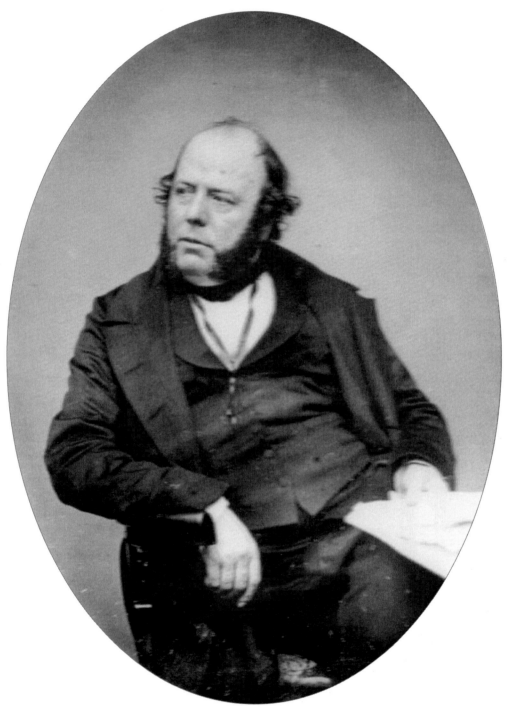

George Felix Gilbert (1791–1861) was Blackheath's first estate agent. He set up his business in Montpelier Row in 1820 and prospered wonderfully in parallel with the fortunes of the expanding suburb. He had several talented sons, the most eminent being Sir John Gilbert, the artist who was the mainstay of the *Illustrated London News*. This daguerreotype portrait was taken in the late 1830s or early 1840s.

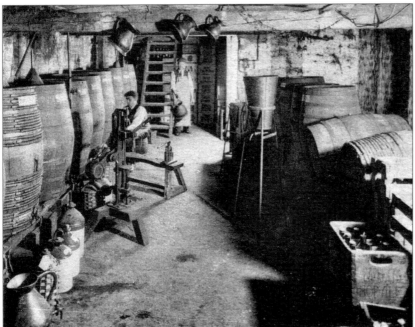

From its origins as a single grocer's shop opened in 1822, Joseph Peppercorn's business grew into Deptford's leading department store, occupying most of the north side of the Broadway. Probably because of the financial weakness that led to its closure in 1916, Peppercorn's was never rebuilt in uniform style, but continued to comprise shops of various dates and styles. Some were large seventeenth-century houses, and beneath them lay hidden the impressive spirit vaults seen here in 1911.

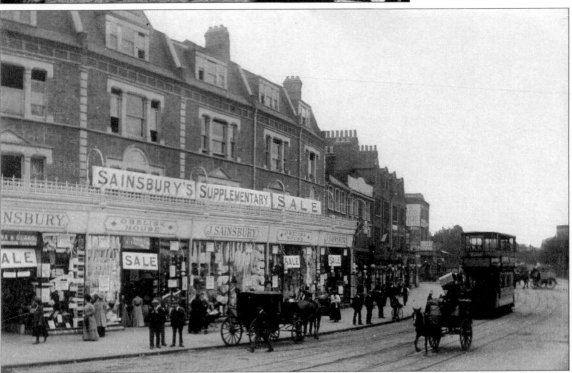

Until recently the only deviation by J. Sainsbury from its familiar grocery business into clothes and furnishings was this accidental one at Lewisham. When Obelisk Buildings, the smart new shops at the corner of the High Street and Loampit Vale, came on the market in the late 1880s two were taken by Sainsbury for food sales and four by a draper called Matthews. He failed in 1902, and Sainsbury took over his business rather than see the parade blighted, and ran it experimentally until 1928. It is seen here in 1910.

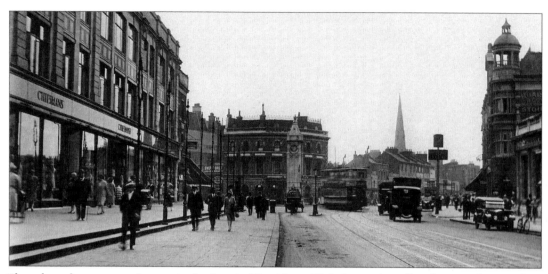

There have been many changes to the heart of Lewisham High Street since this photograph was taken in the early 1930s. Chiesman's department store, on the left, was recently replaced by an enormous police station. The Salisbury pub on the right was demolished in 1959. The Lewisham Methodist Church in Albion Way was destroyed during the war, as were the small shops below its spire. The clock tower has been moved out of the way of the traffic. Only Barclays Bank, behind it, goes on serenely.

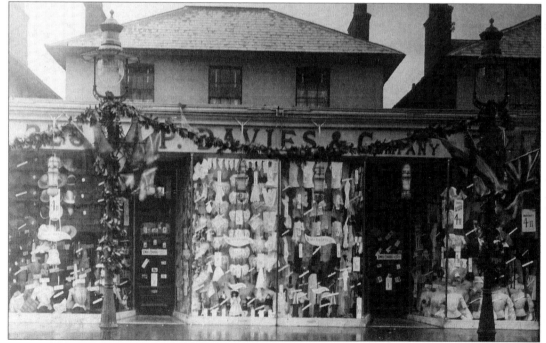

Camden Villas, four houses built in or around 1820 between Lewisham High Street and the pond of the Riverdale Mill, were converted into shops (two per house) early in the twentieth century. The drapers J.P. Davies and Co. started at no. 226 in 1911, and had expanded into nos 224, 224a, and 226a before they closed in 1923. This photograph was taken in 1912. No. 1 Camden Villas, on the right, was demolished when Molesworth Street was widened in the 1990s. The shops in front of the three houses that survive have now been replaced by a Chinese restaurant.

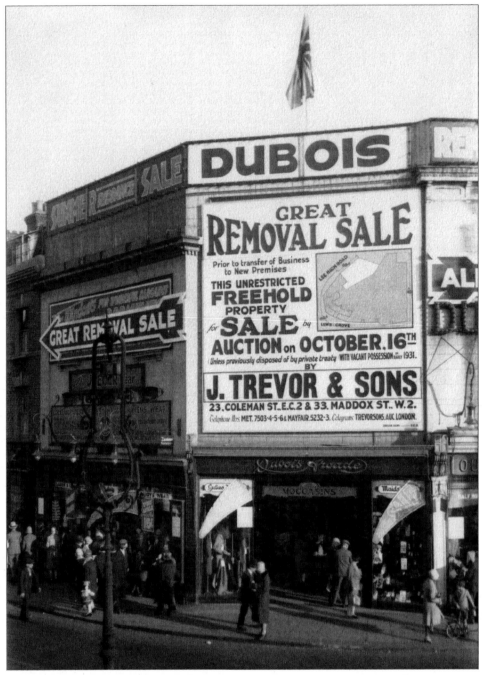

Ernest Arthur Dubois made his Lewisham debut in 1883, as a hatter at 3 Lewis Grove. He gradually expanded his business into a department store that dominated Lewis Grove and even crept around the corner into Lee High Road. When he died in 1927 Dubois's store was a serious rival to Chiesman Brothers in the High Street, but within six years the extravagance and inexperience of his sons had brought the firm to bankruptcy. This 'Great Removal Sale' in 1931 was merely a symptom of the approaching collapse. The photograph shows the corner of Lee High Road (on the left) and Lewis Grove.

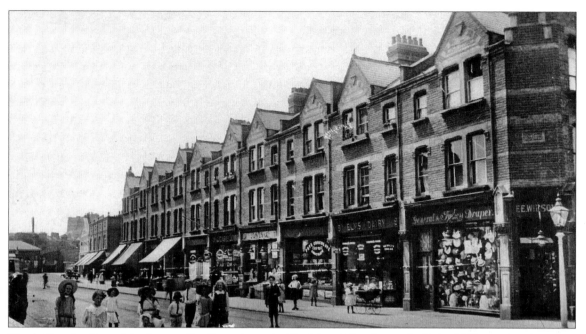

King's Parade, the original name for these shops in Staplehurst Road, was built in 1903, as the plaque on the corner shop records. The terrace was renumbered 37 to 19 Staplehurst Road in 1911, but here in 1915 Elms Dairy at no. 35 is still sporting its old no. 9. On the far left is Hither Green station, and to its right there is a glimpse of a very short-lived cinema, The Globe, which lasted only from 1913 to 1915.

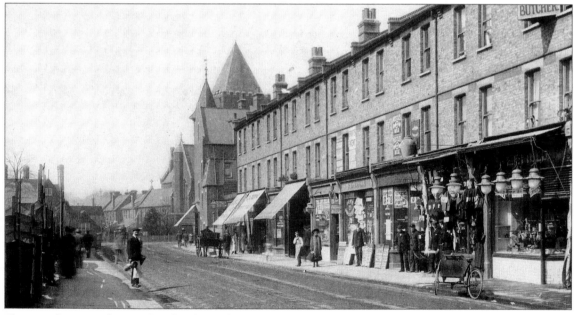

The ten shops on the north side of Sangley Road, between Rushey Green and Plassy Road School, were built by D. & R. Kennard in 1900–1, as Sangley Market. By the time this photograph was taken in 1906 they had become 1 to 19 Sangley Road. All were to be demolished, together with the school, in the 1990s. In 1906 the south side of Sangley Road, so soon to become the centre of Catford entertainment, was just a building site behind an untidy fence. The stubby spire in the background was that of St Laurence's Church.

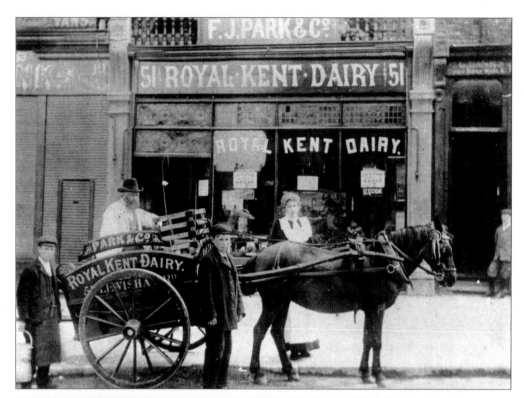

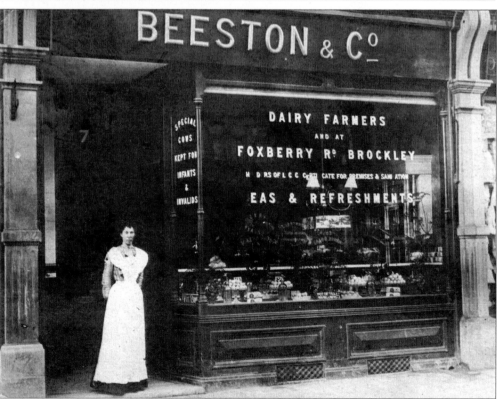

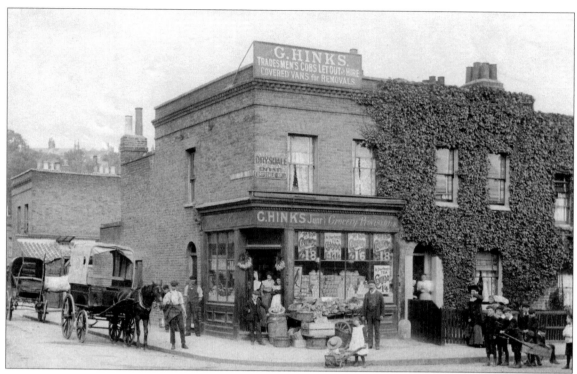

George Hinks had this greengrocer's shop at 25 (formerly 8) Drysdale Road, Lewisham, from 1892 until 1919. This photograph from 1904 shows the large numbers involved in the business, or at least wishing to share in its immortalisation. As his advertisement makes clear, Hinks acted as a removal man, a not uncommon sideline for greengrocers at that time, and also as a horse dealer, which was more inventive. When he gave up the shop he began to operate as a coal merchant from the smaller no. 15, which until then had been just his private address. The original shop, seen here, stood at the corner of Lethbridge Road; the roofs in the distance belonged to houses on the much higher ground of Dartmouth Row, Blackheath. Drysdale and Lethbridge Roads were laid out in 1870, in the exhausted chalk quarry known as Loat's Pits, after Lancelot Loat, a brickmaker of the early nineteenth century. The Drysdale Road houses were built in 1870 – see p. 115 for no. 39 – and those in Lethbridge Road more gradually during the 1870s. The corner shop was destroyed by a bomb in September 1940, like much of the northern ends of the two roads. Soon after the war this area was replaced by Vardon House, Travis House, etc. The southern ends, including 39 Drysdale Road, were swept away in the 1960s, to be replaced by Lethbridge Close.

Opposite, top: F.J. Park ran the Royal Kent Dairy at 51 Lewisham Road from 1890 until 1910. This photograph was taken towards the end of that period. The shop was on the east side, eight or nine doors south of Sparta Street. The area suffered badly during the Second World War, and no. 51 was among the few buildings that survived. It was pulled down soon after the peace. The site is now part of the open space south of Doleman House.

Opposite, bottom: Beeston & Co., dairymen, had two shops in the Brockley area. One was at 79 Foxberry Road. The other, seen here in 1904 or 1905, was at 7 Crofton Terrace, which was soon to become 364 Brockley Road. The shop, two doors south of Holdenby Road, is now a chicken takeaway.

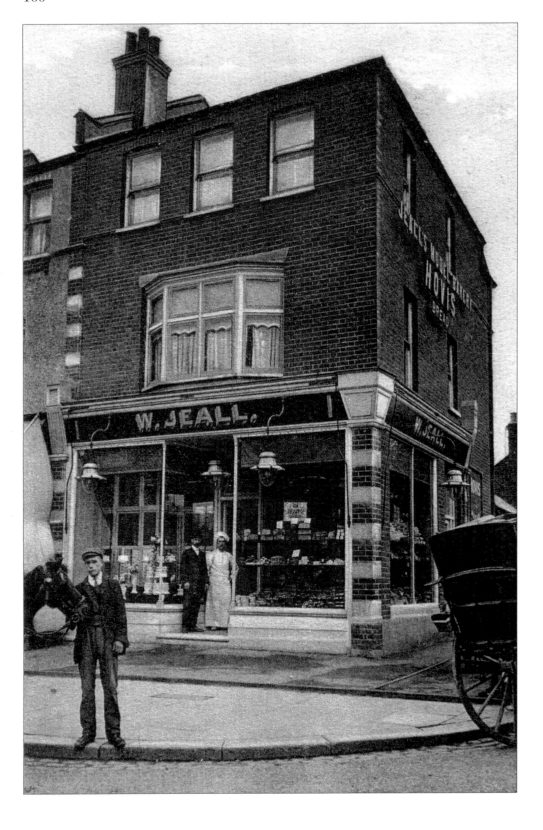

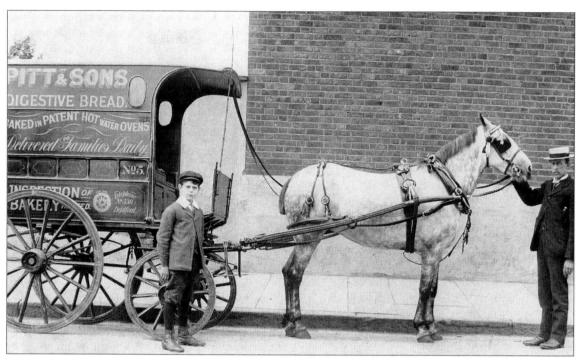

Pitt & Sons, the bakers, were an old established Deptford firm, active for some sixty years. John James Pitt founded his shop at 21, later 386, Evelyn Street before 1874, and in the 1880s he moved two doors west to no. 23, later 382. These addresses were on the south side, just west of Grinling Place (or Wellington Place, as it was known earlier), and close to the bustling world of the High Street. The family remained at no. 382, trading as J.J. Pitt & Sons, until 1930. The building survived until the 1970s, when the Alfred Morris Day Centre was built on the site of this and the neighbouring shops. This handsome Edwardian delivery cart – was it really one of a fleet of five or more? – may have been drawn up in Grinling Place or Clyde Street, which formed the route from Evelyn Street to the firm's stables and cart sheds, of which the entrance was in Clyde Street. The expressions of man and boy are not so welcoming as to reinforce the slogan 'Inspection of Bakery Invited', but they perhaps underline the weary reality of 'Delivered to Families Daily', if persevered with for sixty years.

Opposite: This shop at the corner of Algernon Road and Ladywell Road has been a bakery ever since it was built by D. & R. Kennard of Lewisham Bridge in 1904. It was known at first as 1 Station Buildings, part of a terrace of five shops, but is now 259 Algernon Road. William Jeall began his career at 50 Ladywell Road, but moved to this new and better shop, which was nearly opposite, and remained there until 1919. Jeall, who is presumably the man in the bowler hat, sent this card in 1909.

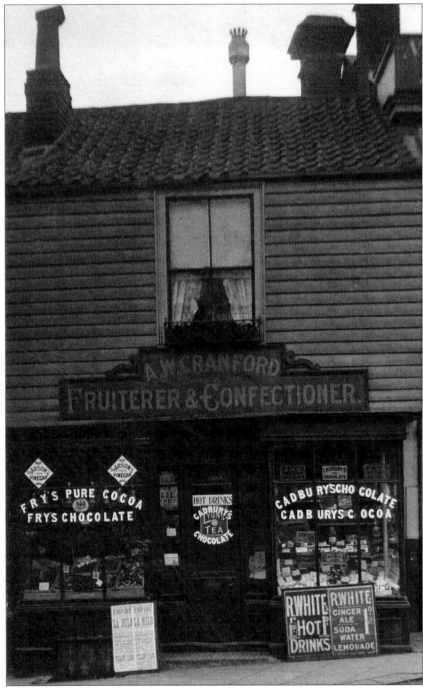

One of the oldest shops in Blackheath, and therefore in Lewisham, is 47 Tranquil Vale, which is seen here in 1909. It was certainly built in the eighteenth century, and possibly before 1745. It forms part of a picturesque group with Collins Square (see p. 114) and the Crown public house, which can just be seen at the top right of the picture. Albert William Cranford had his greengrocery and sweet shop here from 1909 to 1918.

9

Amenities

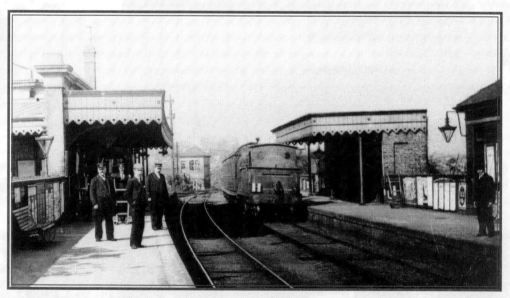

This uncharacteristically tranquil moment on platforms 3 and 4 of Lewisham station, with the staff outnumbering the passengers, was captured early in the twentieth century. This was the original North Kent Line, opened in 1849. In 1857 the addition of the Mid Kent Line, seen in the background branching left into platforms 1 and 2, had led to the rebuilding of the station and its renaming as Lewisham Junction. Between 1849 and 1857 the booking hall was in the High Street, underneath the bridge.

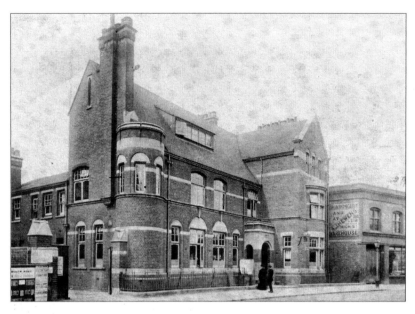

The demolition of Lewisham House in 1893 released space for the enlarged public buildings needed by the rapidly growing town. As the police force was still largely pedestrian, the prime site in the High Street went to the fire brigade. Lewisham Police Station, which got the less convenient Ladywell Road frontage, was built in 1898–9 by Sydney Hart of Croydon. It is seen here soon afterwards. The huge new police station in the High Street has made this building redundant, and it is being converted into flats.

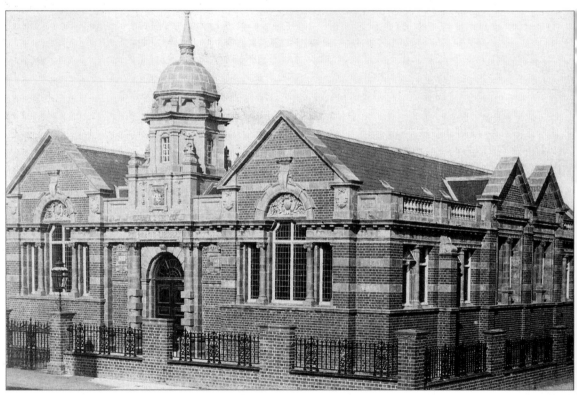

Hither Green Library in Torridon Road, one of the many financed by that extraordinary philanthropist, Andrew Carnegie, was built in 1907, on a site provided by Cameron Corbett. The architect was a surprise choice. In a competition, the design by Henry Hopton of 37 Ringstead Road, Catford, an architectural draughtsman from Bath who was 60 years old in 1907, beat those by eleven more experienced local architects. His fine building survives intact except for its name. It is now Torridon Road Library.

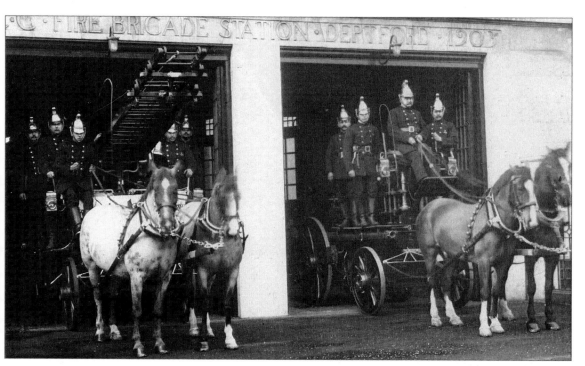

Deptford Fire Station in Evelyn Street was rebuilt by the London County Council in 1903, as the inscription on the building records, partly on the site of a smaller station. This photograph of the engines and their crews cannot have been taken many years afterwards.

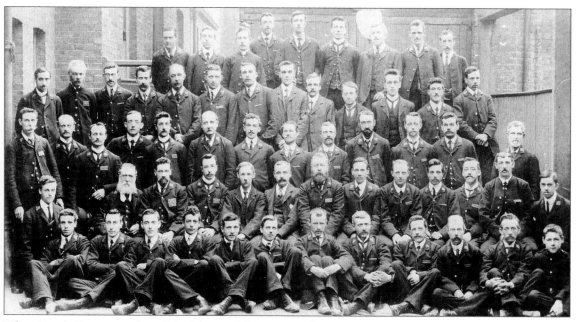

When Brook House was demolished (see p. 33) a postmen's sorting office was built over most of the garden in 1896–7. It was given the number 106 High Street in 1905. Just enough open space was left for these sixty postmen and boys to pose for their portrait in 1906. The sorting office survived until the construction of the Lewisham Centre in the 1970s. W.H. Smith's shop now occupies the site.

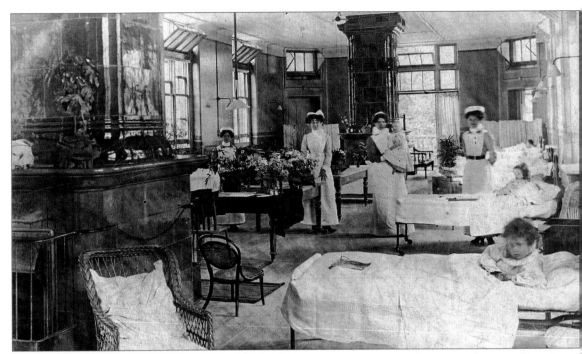

The Park Fever Hospital, later known as Hither Green Hospital, was built by the Metropolitan Asylums Board between 1895 and 1897. The design was by Edwin Hall of Dulwich, who went on to be the leading hospital architect of his generation. This scene in one of the children's wards in 1908 shows the huge tiled stoves that were a feature of Hall's design. Most of the hospital buildings were demolished in the 1990s, and the site is now being densely covered with housing.

Brockley Cemetery has a separate Roman Catholic section that used to boast its own handsome chapel. It was designed by E.W. Pugin and consecrated in 1868 as a chantry for the Knills of Blackheath, a family that produced two Lord Mayors of London. The chapel is seen here early in the twentieth century. With ecumenical impartiality the Luftwaffe destroyed all three chapels at the cemetery, this one in October 1940.

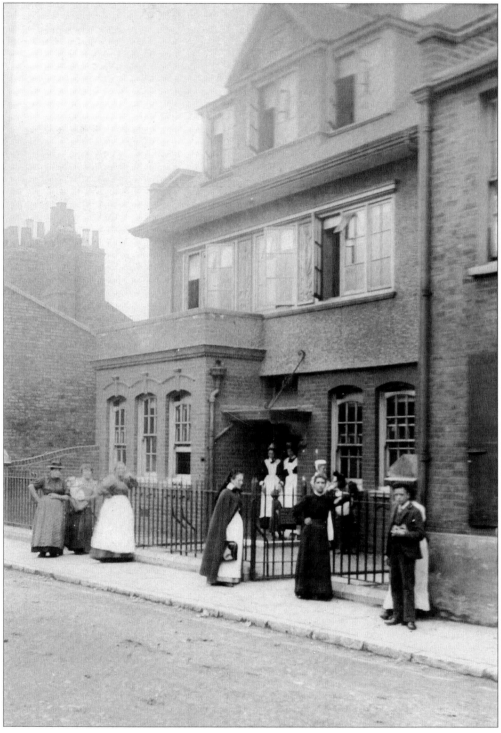

The nurses' home and clinic in Watson's Street, Deptford, seen here soon after it opened, was built in 1898 for the Nursing Sisters of St John the Divine, an Anglican sisterhood founded in 1848. The nurses moved out in the early 1970s.

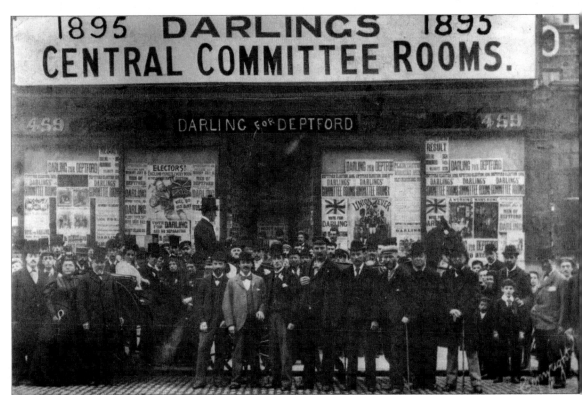

Charles Darling (1849–1936), a diminutive barrister and journalist, who was Conservative Member of Parliament for Deptford from 1888 to 1897, enjoyed (in some quarters) the nickname of 'Deptford's Darling'. He is the man in the top hat, seated in the carriage. Darling gave up politics on being made a judge, in which capacity he was famous, or notorious, for his jokes and flippant remarks, even when presiding in murder cases. He was given a peerage in 1924, the year after his retirement. Darling's committee rooms for his 1895 Deptford campaign were at 459 New Cross Road, on the stretch between Mornington Road and Watson's Street, and not far from the Deptford Conservative Working Men's Club at no. 411. The large no. 459 was empty in 1894, but from 1895 was occupied by the banner painter William Boughton. As he specialised in trades union banners, it is more likely that the Conservatives hired the shop before Boughton took it over than that he lent it to the Darling campaign.

The Hatcham Liberal Club in Queens Road was built in 1910–11. It was the third or fourth home of the club, which had been founded in 1880, if the inscription over the door is correct. This postcard was sent in July 1911, presumably by the first steward of the new building, who has indicated his rooms on the top floor.

Lewisham Town Hall in Catford Road was enlarged and thrown out of proportion in 1900, to house the newly formed Lewisham Council. The extension comprised the five bays and porch to the left of this photograph, which must have been taken soon after the alterations were completed. The original part (for which see p. 61) was built in 1874–5 as the offices of the Lewisham Board of Works. The old town hall was demolished in 1968, and has been replaced by the civic suite.

The railway from Nunhead to Shortlands, known as the Catford Loop, was opened in 1892 to relieve pressure on the London, Chatham and Dover Company's main line. Beyond Catford the new tracks were little used for commuter traffic, Bellingham and Beckenham Hill, where cows outnumbered humans, being among the quietest stations in London. When this photograph was taken in 1923 things were changing dramatically at Bellingham, with the building (left) of the big London County Council estate.

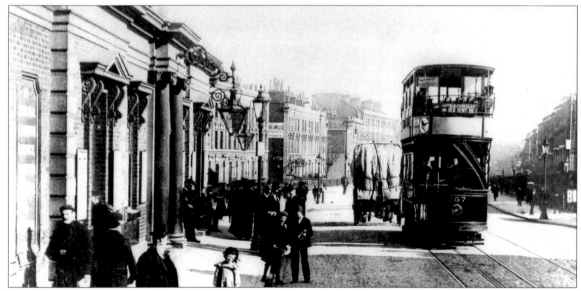

When New Cross on the North Kent Line, seen on the left, was opened in 1849 it meant that there were two stations of the same name within half a mile. What is now New Cross Gate had been opened as New Cross in 1839 by the London and Croydon Railway, and the rival companies refused to distinguish the two, to the confusion of generations of passengers. Clarity had to wait until amalgamation in 1923. This Edwardian photograph shows the view from the booking hall in New Cross Road (now demolished) eastwards towards Deptford Broadway.

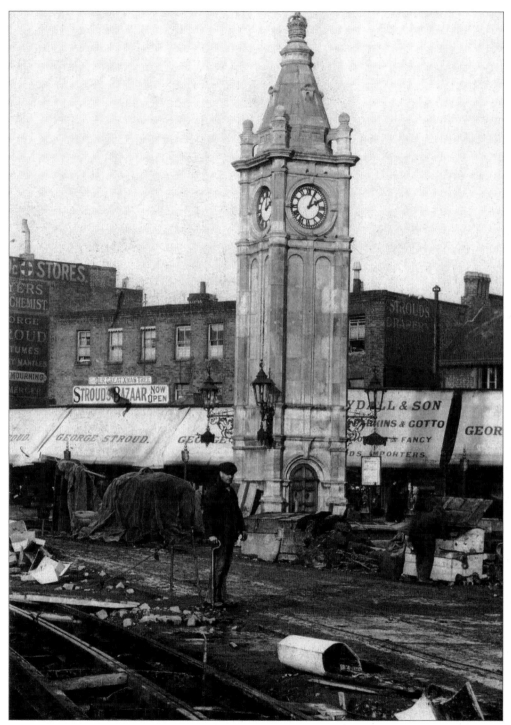

It looks like the aftermath of some dreadful disaster, but was in fact only the laying of the tramlines down Lewisham High Street in the winter of 1905–6. It was a scene of chaos to be repeated in most of Lewisham's main roads in the years up to the First World War. The man who sent this postcard in April 1906 wrote 'This is the muddle we have been in; straight now.'

This well-patronised no. 91 bus is pictured in Adelaide Road (now Avenue) during the summer of 1917. It is passing Hilly Fields and the corner of Montague Avenue. This was a short-lived Thomas Tilling service that ran from Plumstead to Sydenham only from March to August 1917. It was subsidised by the Ministry of Munitions to serve the armament factories of Woolwich and Plumstead.

By 1920 the London General Omnibus Company had wiped out all its serious rivals except Thomas Tilling, but in 1922 a new independent operator began a trend by challenging the combine on one of its prime routes. Soon there were nearly three hundred pirate companies in London, one of them calling itself 'Genial' in close imitation of the LGOC's 'General'. The crisis put at risk the less profitable country services, like this no. 136, seen at Grove Park station in 1926.

10

Housing

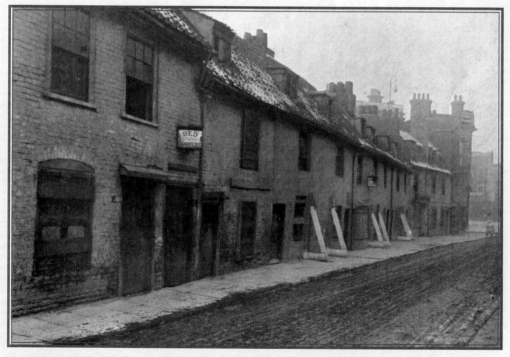

During the nineteenth century these old buildings in Brookmill Road, formerly Mill Lane, degenerated into the worst slums in Deptford. They were all lodging houses, patronised by criminals, prostitutes, and successive waves of destitute immigrants. This photograph shows them in 1899 when awaiting demolition. The London County Council had condemned them, and in 1903 was to build the huge common lodging house known as Carrington House on the site.

Collins Square was an enclave of wooden cottages tucked away behind the Crown in Tranquil Vale. It was built late in the eighteenth century and named after the family that held most of the land to the west of Blackheath Village. The square decayed and dwindled until, when this photograph of no. 3 was taken in 1957, there were only three cottages left. They were soon threatened by a slum clearance order, but a campaign led by the Blackheath Society ensured their preservation and restoration.

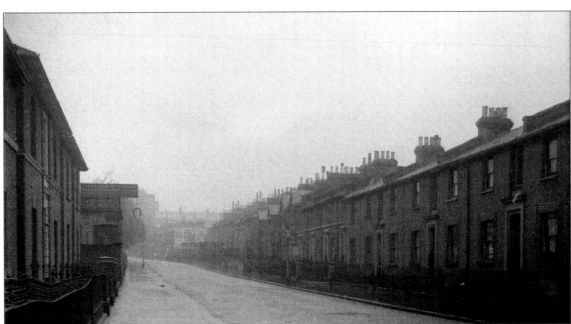

Turner Road, although it conformed in style and status to working-class Lee New Town, which it adjoined, was built a decade or two later, in the 1850s, on land belonging to Sir Gregory Page Turner. This was the view from the Lee High Road end shortly before the First World War. Because the back gardens of Lee Church Street stretched almost, or entirely, to Turner Road, there were few houses on the left-hand side. One, advertised by the dangling horseshoe, was Hollett's forge. All of these houses have been demolished, and Turner Road has been absorbed by Dacre Park, formerly its northward continuation.

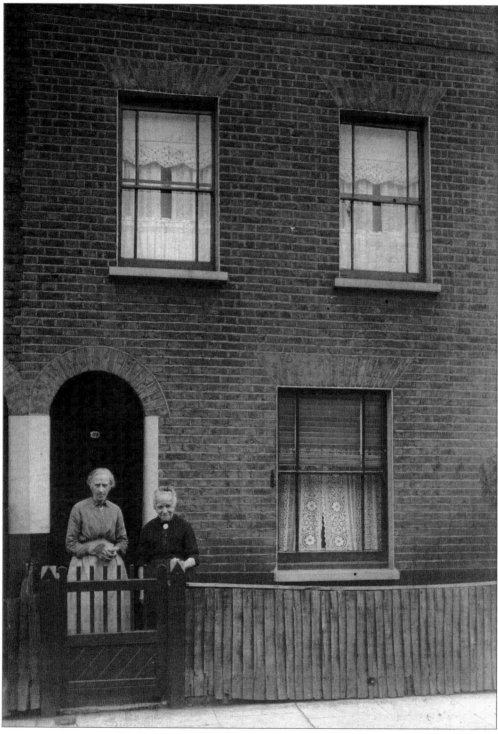

No. 39 Drysdale Road was built in 1870. It was the seventh house south from Hinks's shop. See p. 99 for that, and for more about Drysdale Road. One of the ladies at the gate was the widow of George Barnes, a bricklayer who died in or around 1900.

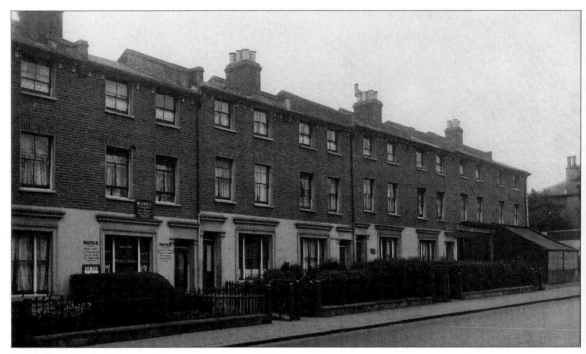

This postcard from the First World War period shows 95 to 109 Catford Hill. The houses were part of a terrace of sixteen, now known as 81 to 109 Catford Hill, that was built in the mid-1860s and originally called Alexandra Terrace, after the new Princess of Wales. On the right are 107 and 109 Catford Hill. They were the only ones built as shops, but they have now been converted into houses. Walter Cable, the boot repairer whose sign can be seen on the left, was at no. 97 from the first decade of the twentieth century until the beginning of the Second World War.

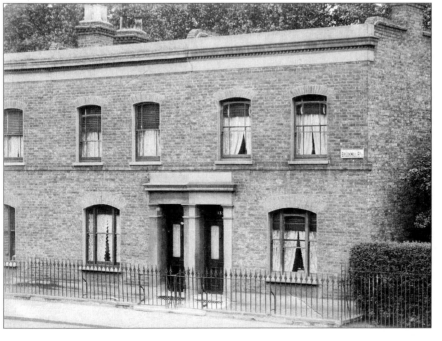

These terraced houses of the 1880s, 133 and 135 Brookmill Road (formerly 93 and 95 Ravensbourne Street) stood next to the old Greenwich Park railway line. Only the entrance to the Ravensbourne Recreation Ground, on the right, stood between them and the railway bridge, now removed. These houses were bombed in 1940, together with the almost forgotten Emmanuel Church that stood behind, and the site is now included in the enlarged Ravensbourne Park.

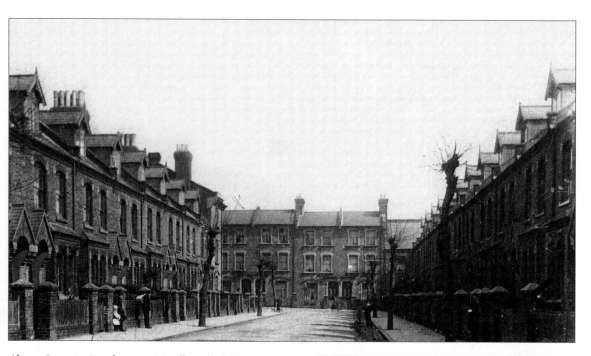

Above: Quentin Road was originally called Cleopatra
Grove, but sadly the name was changed in 1883.
It was built in 1879–80 by the National Dwellings
Society Ltd, which put up tenement blocks on the less
restricted part of the site around the corner in Dacre
Park. This was a classic shabby-genteel road, where
the houses made a brave show, but had little depth and
no gardens. The mother of Ernest Dowson, the poet,
when reduced from wealth to poverty, hanged herself
here in 1895. This is the view from the north end in
the early 1920s.

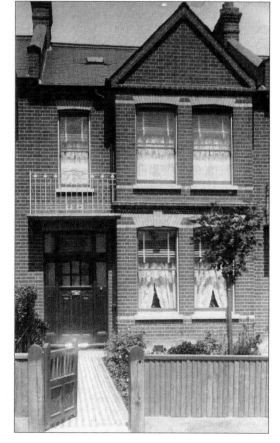

Cameron Corbett left the eastern end of Brownhill
Road until a late stage in his development of the
St Germans Estate. The terrace of eight houses on the
north side, at the corner of Hither Green Lane, was
not built until 1910. This postcard of one of them,
no. 343, was sent in the next year by William Green,
the proud new owner. The house is a good example
of the neat and solid workmanship that Corbett
demanded from his builders.

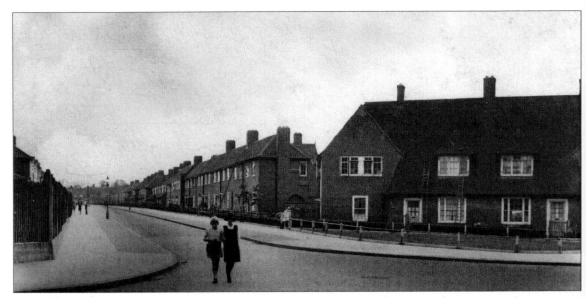

The Downham Estate was built by the London County Council between 1924 and 1930, mainly to rehouse people displaced from inner South London by slum clearance. Many of the roads were rather desperately named, for no obvious reason, after the Knights of the Round Table, but a few had local significance. This is the new and raw Rangefield Road, as it looked in the late 1920s. It stood on the site of the Lewisham Rifle Range, which had been established during the Boer War.

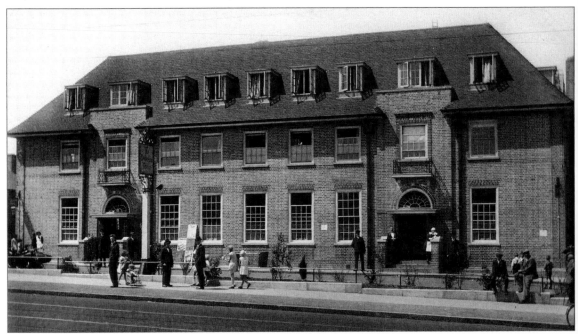

The London County Council realised that its tenants on the Downham Estate would still get thirsty despite their move to the country, but instead of the small corner pubs they were used to it provided the Downham Tavern, one of the largest in the country. It certainly claimed to have the longest bar. The Tavern is seen here shortly after it was opened in 1933, with some of the uniformed staff outside. In recent times it fell into disrepute, and was demolished. A smaller version has been built on part of the original site in Downham Way.

It is a measure of the ambition of the housing department of Deptford Council in the 1940s that in a bomb-ravaged borough their complaint was of a shortage of building sites. Nevertheless, they managed to do a great deal in a few years. As often happened with public housing schemes, the original low-rise ideal was soon abandoned under economic pressure and the interested advice of the architects appointed, whose experience was all in the design of flats. They were H.V. Ashley and Winton Newman, who secured the contract to oversee all the council's 1940s housing schemes. Among the first were Larch House and Beech House, on the south side of Clyde Street, which were built in 1947. A kitchen from the newly completed Beech House is seen above, with the backs of some doomed eighteenth-century houses in Edward Street visible through the window. The star item from the Second Year Permanent Housing Programme was Maple House, at the corner of Idonia Street and Payne Street, which was built in 1948–9. It is seen below soon afterwards.

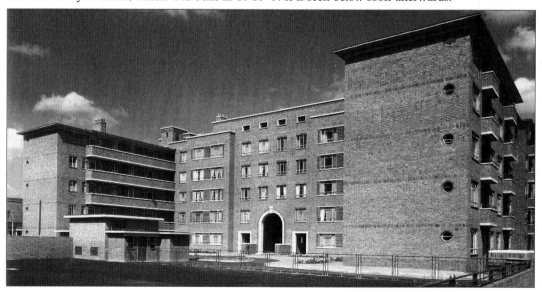

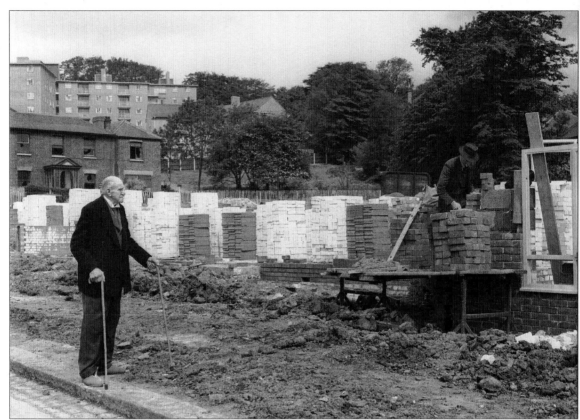

Rosamond Street in Sydenham was named after Mrs Rosamond Edney, who was the widow of Thomas Edney, the village blacksmith. She took over the business when he died and appeared in directories and census returns as Rosamond Edney, smith and farrier, though the heavy work was presumably done by her adult sons. The Edneys had owned their forge and four adjoining cottages in Sydenham Road since the late eighteenth century, and this freeehold entitled them to a small allotment of land on Sydenham Common when it was enclosed in 1810. On this plot north of Wells Park Road the family built Edney Street in 1860–1 and Rosamond Street in 1862–3. By the early 1950s, after a decade of bombardment and building restrictions, the Rosamond Street houses were in poor condition. They belonged to John Lidle of Forest Hill in 1956, when the London County Council, just beginning its great Wells Park Road clearances, served him with a compulsory purchase order. He was doubly unfortunate, because the LCC was also determined to get possession of his own home in Dacres Road, around which it was building blocks of flats and a school. This photograph from May 1958 shows Mr Lidle in Rosamond Street, protesting at the fact that his houses had been demolished (and that their replacements were rising) despite the fact that he had not agreed a price for their sale. An LCC spokesman said, 'Private negotiations do not interfere with public work'. The derelict building in Springfield Road, above Mr Lidle's head, had been the office of the Crystal Palace District Electric Light & Supply Company, and before that the proprietor's house of the Springfield Brewery. Rising menacingly behind it is one of the recently built blocks of flats on the LCC's Sydenham Hill Estate. That was the fruit of another compulsory purchase, this time from Brompton Oratory.

11

First World War

The Lewisham war memorial, on the High Street frontage of Lewisham Park,
was unveiled in May 1921. The entrance piers, now lacking their lamps,
were in memory of the dead of the 11th (Lewisham) Battalion of the Royal West Kent
Regiment. The memorial and piers were designed by the Catford architect E.A. Stone,
who was much better known for his cinemas and theatres.

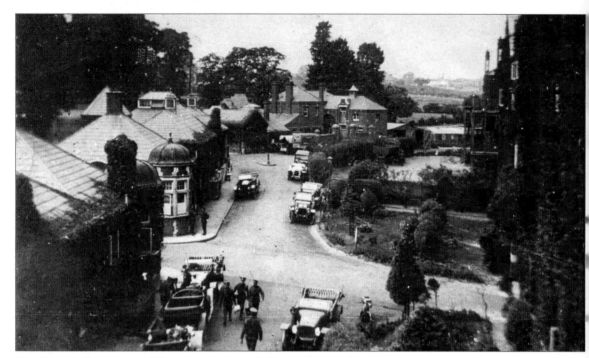

The Greenwich Union Workhouse at Grove Park, later Grove Park Hospital, was occupied by the Army Service Corps as its No. 1 Reserve Mechanical Transport Depot throughout the First World War. This was the courtyard between the entrance lodges on Marvels Lane, seen on the left, and the ivy-covered administration block. The photograph must have been taken early in the war, as the ivy did not long survive the military takeover.

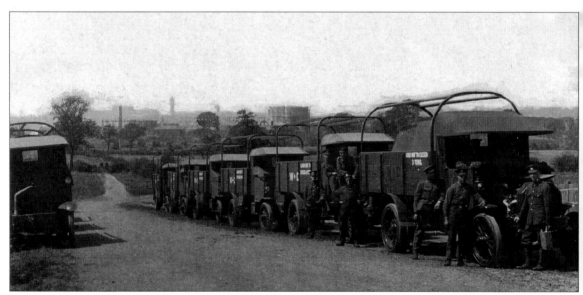

All the roads for miles around Grove Park were clogged with the vehicles of the Army Service Corps. This one was later to be known as Randlesdown Road, but in 1915 it was just the approach to Bellingham station. To the west it dwindled into the footpath seen here meandering across the fields to Sydenham. The gasometers at Bell Green can be seen in the distance, with the Crystal Palace on the horizon. Within ten years all this countryside was to be covered by the Bellingham Estate.

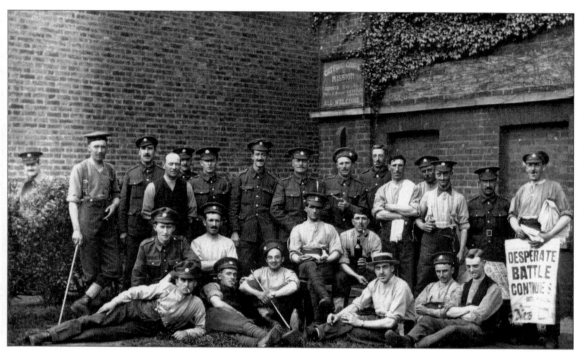

For a few heady years in the 1890s the Catford Cycling Club's track, which lay between Brownhill Road and Sangley Road, was one of the sporting attractions of London. Its most notable feature was the pavilion, which had an ornate pagoda roof. When the growing demand for building land in the area led to the closure of the track the pavilion somehow survived. With the seats removed and the open side walled in, it became a bizarre feature among the terraced houses of Sportsbank Street, which were built in 1902. Over the years the Sportsbank Hall, as it was called, was turned to many diverse uses. It began as a drill hall for the West Kent Yeomanry, and was then used as a chapel by several Nonconformist groups. The last of them, the Catford Gospel Mission, still had its notice on the wall when this photograph was taken during the First World War, but by then the building had been requisitioned, like so many others in the area, for use as an Army billet. These cheery soldiers called themselves 'the Sports of Sports Bank Hall'. Between the wars the old pavilion served as a dancing school, a public hall for hire, and a British Legion Club. Finally, in the 1950s, it became the warehouse of a sweet wholesaler. The building was disfigured in 1982 by the removal of the pagoda section of the roof, and was finally demolished in the early 1990s. Eleven houses known as Fleet Terrace have been built on the site.

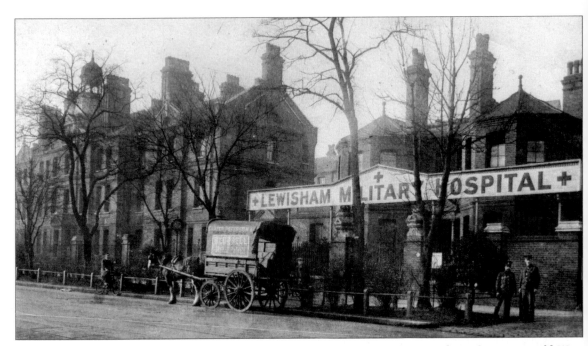

Lewisham Workhouse, now Lewisham Hospital, was converted to military use early in the First World War. The photograph above shows the Infirmary (which was built between 1892 and 1894 at a cost of £74,000) in its days as the Lewisham Military Hospital. The Infirmary had made the first physical distinction between the workhouse and hospital functions carried out on the site by the Guardians of the Poor. The operation, or mock operation, seen below, took place in 1918. Surgery was a major part of the work of the military hospital. Lewisham did not have purpose-built operating theatres until 1924, but since 1895 surgeons had used a room in the female section of the Infirmary, later Block E, as a makeshift theatre.

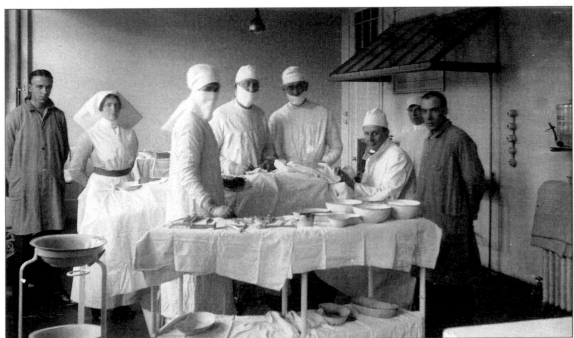

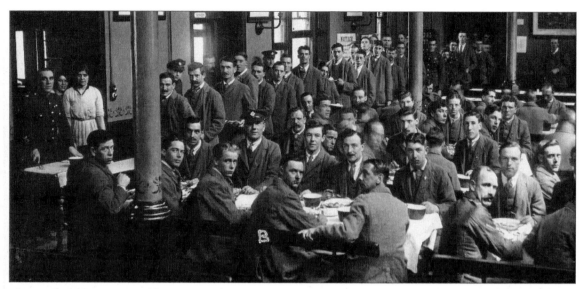

The St Olave's Union Workhouse was opened at Ladywell in 1900 because there was no room for such a large new building in the crowded streets of Bermondsey, Rotherhithe and Southwark, parishes from which made up the union. It was intended for the aged and infirm poor of those districts, but the old people were soon forced out by the emergency of the First World War, when the workhouse became the Bermondsey Military Hospital. Some of the convalescent soldiers are seen above at the tables more often occupied by rows of old ladies in headscarves. The bottom picture also shows some of the medical staff. The workhouse was later an old people's home under the name of Ladywell Lodge, but it has now been largely demolished.

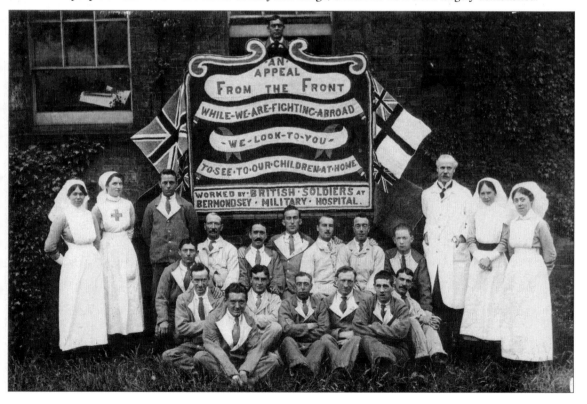

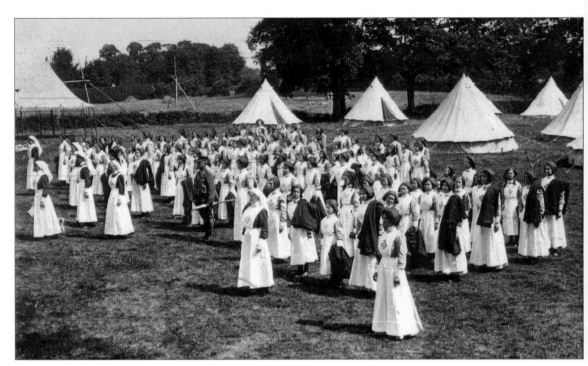

This postcard has on the back the ambiguous inscription '1918 Red Cross Camp Ladywell Lewisham Park, Lily second from front on the right'. The identity of Lily will never be ascertained from this clue, but the venue must be Ladywell Recreation Ground (now Ladywell Fields) rather than Lewisham Park. The young volunteers were presumably receiving instruction from nurses at the adjoining Lewisham Military Hospital.

The extent to which large parts of Lewisham were overrun by the Army during the First World War is suggested by this photograph of the normally sedate and peaceful Lee Terrace, as it appeared in 1918. The view is towards Blackheath Village from the crossroads created by Dacre Park on the right and The Glebe on the left.

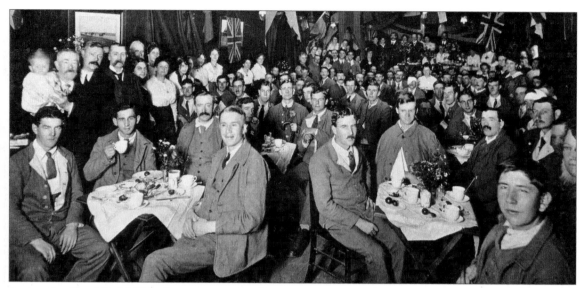

During the First World War the precarious health of wounded soldiers must often have been threatened by the stampede of organisations anxious to entertain them. This tea party was given by the Deptford Tariff Reform Club at 114 New Cross Road (next to the old library) on 5 October 1916. The sixty-five soldiers, who were regaled with whist and songs, were from King's College and the Brook Hospital.

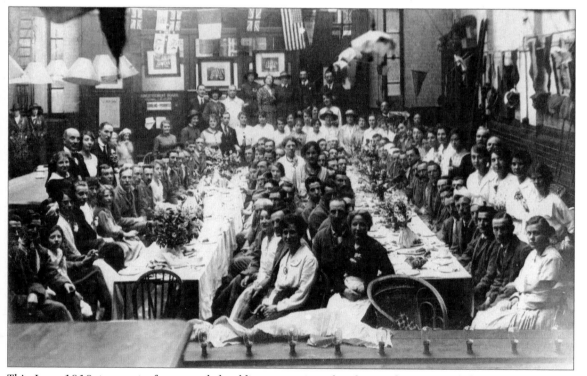

This June 1919 tea party for wounded soldiers was given by the conductresses of the New Cross tram depot, presumably in the staff canteen. Note the men's hospital uniforms, also seen in the Ladywell Lodge photograph on p. 125. The clippies were beginning to stand down from war service as the men returned from overseas, but some are still seen in uniform at the back of the room.

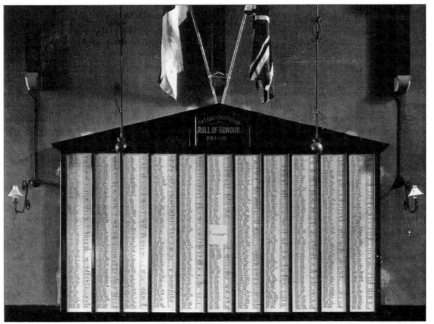

During the three or four years after the First World War schools, clubs, offices, factories, organisations of every kind rushed to erect memorials to their war dead. Churches were in the forefront of the movement. A good example is this Roll of Honour from St Luke's, Evelyn Street, Deptford, seen here when new and beautifully tended. It is also typical of the contrast between original care and modern neglect. This monument is no longer visible and it is not even certain that it survives.

The memorial to the war dead of the 1/20th and 2/20th Battalions of the London Regiment was unveiled at the north-eastern corner of their Holly Hedge House headquarters (see p. 189) on 10 April 1920. It was moved from its original position in the 1950s, perhaps to get it away from the Hollyhedge Bungalows, the post-war prefabs that were built up against it. It is now at the western edge of the enclosure, and faces in towards the base rather than outwards to the Heath and the world.

12

Looking Down on Lewisham

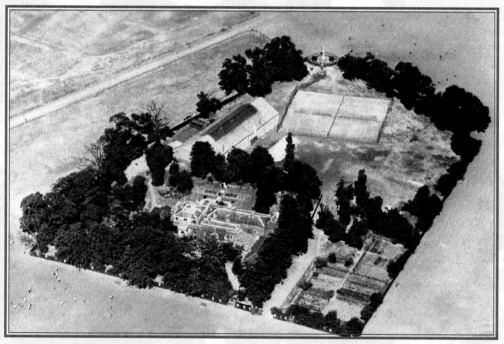

Holly Hedge was an early encroachment on Blackheath, established by the late seventeenth century around a windmill and a miller's house. The enclosure grew during the eighteenth century, the house was rebuilt as a gentleman's residence, and eventually the windmill was removed. In 1888 Holly Hedge House became the headquarters of the various local volunteer corps, and it has remained in military use until today, even though the house was demolished in 1946, after bomb damage. This 1920s aerial view from the south-west shows the house in the foreground, the drill hall behind it, the parade ground to its right, and the war memorial (see p. 128) in the distance.

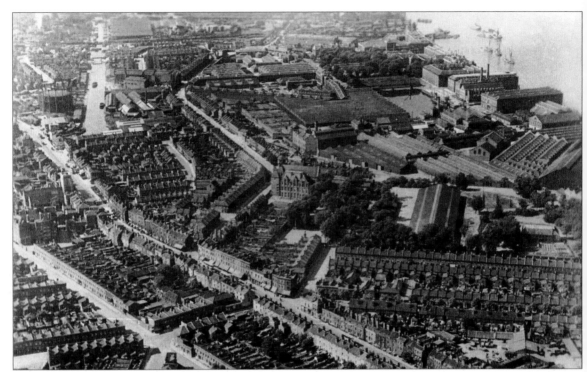

This 1920s view of north Deptford features the sources of its two periods of industrial growth. Top right is the Thames, which gave rise to the ship-building, fitting, provisioning, and repairing activities that promoted Deptford from an obscure fishing village to a bustling town. As Thames shipbuilding declined early in the nineteenth century, plunging Deptford into an employment crisis, along came the Grand Surrey Canal, opened in 1809, to provide facilities for a new generation of employers, working mainly in the fields of engineering and chemicals. The canal, its banks crowded with factories and wharves, can be seen top left, crossing Evelyn Street at Blackhorse Bridge, then turning sharply north to seek its eventual outlet at the Surrey Docks. Relics of the earlier phase of Deptford industry appear on the right of the photograph. On the edge is a part of the former Royal Dockyard, which finally closed in 1869. In the mid-1920s it had finished its stint as London's Foreign Cattle Market and had been taken over by the Army as a supply depot. This area is about to be intensively redeveloped as housing. Beyond it lay the Royal Victoria Victualling Yard, the Navy's supply depot, which became the site of the Pepys Estate in the 1960s. At the top of the picture, past the Victualling Yard, was Deptford Wharf (see p. 92) which was formerly Dudman's Dock, a private shipbuilding yard. The two main roads in the picture are Evelyn Street, which runs from bottom right to top left, and Grove Street, which turns off Evelyn Street to the right and heads north towards Surrey Docks, weaving between the Victualling Yard and the canal. The main feature in Evelyn Street was St Luke's Church, with its squat tower. Just below it was Alverton Street School, which was formerly known as Duke Street and later as John Evelyn. In Grove Street the most prominent building, in the centre of the picture, was the Grove Street School, for which see p. 54. The open space to the right of the picture was the remains of Sayes Court Gardens, seen in happier days on p. 71. The low building near the right edge of the picture was the former St Nicholas parish workhouse, built in the 1720s on the site of John Evelyn's Sayes Court manor house.

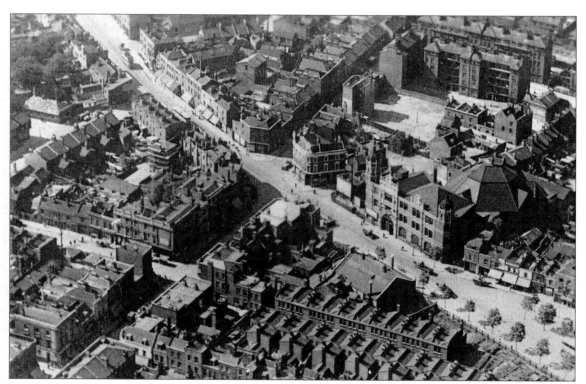

At the centre of this 1920s photograph is the junction formed by Deptford High Street, running in from the bottom left corner, Evelyn Street, coming from top left, New King Street and Watergate Street, branching to left and right of the big Harp of Erin pub, and Creek Road, which leads to the bottom right corner. The first four were ancient, but this part of Creek Road was a newcomer, cut through by the London County Council in the 1890s. An aerial view makes clear the considerable disruption to the old street pattern that was caused by the alteration. Until the LCC got to work there were three roads running at right angles between the High Street and Church Street, which is just out of sight to the right of this picture. The least disturbed of the three was Albury Street. Its junction with the High Street and a few of its fine early eighteenth-century houses can be seen at the bottom. At the Church Street end of Albury Street the new road required the demolition of a few houses. Lamerton Road (formerly Queen Street) was more severely truncated. The terrace on the north side can be seen ending abruptly in waste ground towards the bottom right of the picture. The third road, Wellington Street, was half obliterated. All the western or High Street end was lost, and the fragment that survived at the Church Street end was later renamed McMillan Street. The shops bottom right, three of them with awnings out, were part of Wellington Street. These changes created sites for several new buildings. The Harp of Erin was the chief beneficiary. Until the 1890s it had been a small beerhouse a few doors down New King Street. The necessary demolitions gave it an enlarged corner site, and the pub was rebuilt on the grand scale seen here, nearly in the centre of the picture. The other new buildings visible are the post and sorting office on the south side of Creek Road, and opposite to it the massive Methodist Central Hall, for which see p. 44. The London County Council had also been busy in the top right corner of the picture, between Creek Road and the Thames, building flats to replace decaying seventeenth- and eighteenth-century houses. The blocks seen here were in Blake Street, which runs from New King Street to Watergate Street. They were built between 1895 and 1904. On the near side of them can be seen the disintegrating Rowley Street (formerly Queen's Street) which was soon to vanish altogether and become the site of more LCC flats. To the left of the picture are Edward Street, branching from the High Street beside the White Swan, and Grinling Place, running north from Edward Street to Evelyn Street.

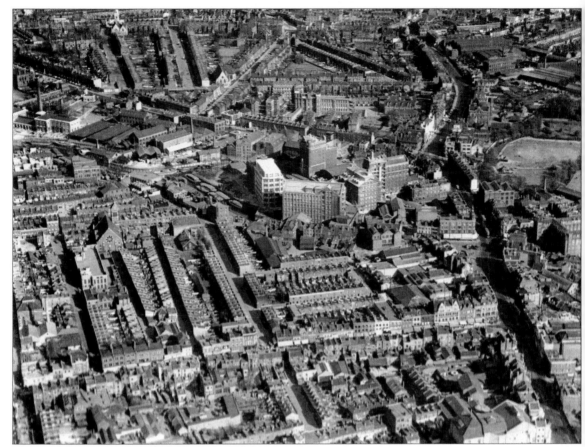

This 1920s aerial view is best navigated via the main roads. The major highway that follows the right edge of the picture is the A2. It gets through five names even in this short stretch: from bottom to top, New Cross Road, Deptford Broadway, Deptford Bridge, Blackheath Road and, in the far distance, Blackheath Hill. The three most prominent turnings to the left are Deptford High Street, which cuts across the bottom of the picture, Deptford Church Street, which begins at Gardiner's Scotch House in the Broadway (see p. 16), and Greenwich High Road, which runs up towards the top left corner. The tall buildings near the centre of the picture were two great flour mills. The nearer four blocks, one of them just completed, belonged to Robinson's Deptford Bridge Mill (see p. 92). These were all swept away after a fire in 1970. Behind them, close to Greenwich High Road, is the grain silo of Mumford's Mill, designed by Sir Aston Webb, and built in 1897. That has lately been converted into flats. Deptford Creek, the last stretch of the Ravensbourne, followed several channels around and between the mills. Note the six barges on one arm of the river between Church Street and the new Robinson's building, waiting either to deliver grain or to collect flour. The big industrial complex further downstream (with the tall chimney near the top left corner) was the Deptford Sewage Pumping Station. In the top right corner, in Blackheath Road, was the former factory of John Penn, the marine engineer. At this time the greater part was being used by a tin box manufacturer. On the right edge of the picture is the tall, stark mass of Carrington House, for which see p. 133. The big building with the tower towards the left edge of the picture was Christ Church in Church Street, which was to be declared redundant and demolished in 1936. The name of the street did not derive from this Victorian church, but from the ancient St Nicholas at Deptford Green, to which it led. The large, flat-roofed building just below Christ Church is Frankham Street School. Deptford High Street is still quite well preserved, but nearly all the other buildings on the near side of Greenwich High Road have been destroyed in the eighty years since this photograph was taken.

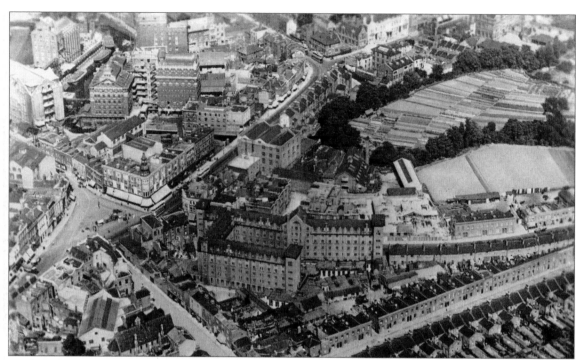

The open space near the left edge of this mid-1920s aerial view is Deptford Broadway, with Church Street branching off to the left, Deptford Bridge towards the top, Brookmill Road to the right, and Harton Street to the bottom of the picture. The junction at top centre is where Deptford Bridge divides into Blackheath Road, to the right, and Greenwich High Road to the left. The road cutting across the bottom right corner is Vanguard Street. The large building in the centre foreground is Carrington House (see p. 113), the London County Council common lodging house that has now been converted into flats as Meretown Mansions. Above Carrington House, nearly in the centre of the picture, is Holland's great gin distillery on Deptford Bridge. Other notable buildings are the huge Robinson's and Mumford's flour mills on Deptford Creek, top left (see p. 132), Gardiner's Scotch House, with its prominent turret, at the corner of the Broadway and Deptford Bridge (see p. 16), and the showroom of Haycraft the ironmonger, bottom left. This was in the angle between Harton Street and the Broadway, in both of which Haycraft had shops communicating with his large hall. The ecclesiastical building in Harton Street was the St John's Mission Hall. The fields top right, so surprising a sight this close to the heart of Deptford, belonged to the Metropolitan Water Board. The more distant one was the market garden where the Deptford Pink, a variety of carnation, had once flourished. The last tenant was Henry Simpson, who rented it from the Water Board on a yearly agreement. That was ended in 1929 when Deptford Council decided to acquire the land as a park. It was opened in 1932 under the inspiring name of the Deptford Municipal Playing Fields, later changed to Broadway Fields. The land on the near side of the Ravensbourne was added to the park in the late 1930s.

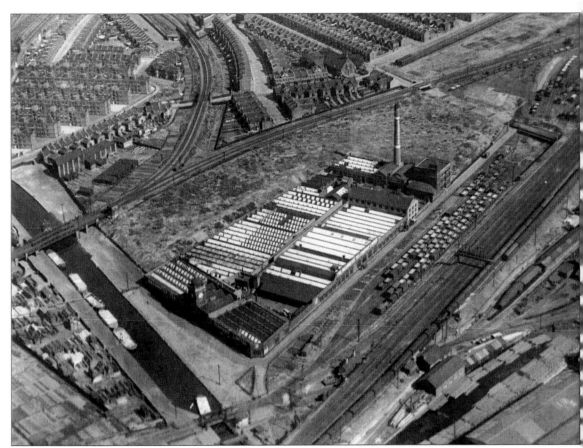

The main feature of this mid-1920s aerial photograph is the Mazawattee Tea Company's factory at New Cross. John Lane Densham became a partner in his family's old-fashioned City of London tea business in 1886, gave it a memorable new name, introduced packet tea to overcome fears of adulteration, turned the firm into a limited company in 1896, and built this great factory in 1901. It was intended for the processing of tea, cocoa, chocolate and coffee, as Densham had diversified when tea profits fell in the 1890s. The site chosen was surrounded with transport services. In front was the Grand Surrey Canal, which cuts across the bottom left corner of the picture. (The curious enclosure on the opposite bank was a petroleum store.) Along the west side of the factory (the right of the picture) ran the London and Brighton railway line, which was opened as the London and Croydon Railway in 1839. On the other side of the factory was the East London Line, with its two branches leading to New Cross and New Cross Gate. It was opened in 1869, using Brunel's old Thames foot tunnel to cross the river. Metropolitan and District Line underground trains began to run on the East London Line in 1884. The bridge seen at the bottom of the picture took the Deptford Wharf branch (see p. 92) across the Surrey Canal. An ingenious lift bridge was required because the line had to be at ground level to pass under the London and Brighton and London and Greenwich viaducts. Other features close to the factory in the 1920s were the Archangel Wharf, bottom right, for which see the opposite page; Folkestone Gardens, Trundley's Lane, top left, a monstrous group of tenements built in the late 1890s by the South Eastern Railway Company; and the old St Michael's Church at the corner of Knoyle Street and Sandford Street. The Mazawattee Tea Company was already in decline when the destruction of both its Tower Hill headquarters and the New Cross factory early in the Second World War proved the fatal blows. What little survives of the factory today is part of the Elizabeth Industrial Estate, north of New Cross Gate station. The canal is now represented by Surrey Canal Road.

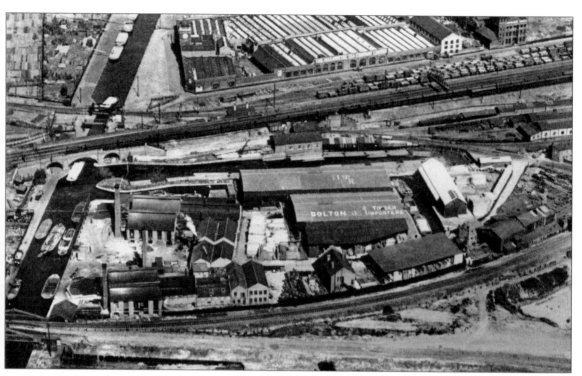

Just west of the Mazawattee factory (see opposite) which can be glimpsed at the top of this picture, and on the other side of the London and Brighton railway viaduct, lay the Archangel Wharf, occupied from the first decade of the twentieth century until the closure of the Surrey Canal in the late 1960s by Dolton, Bournes & Dolton. They were importers of timber, presumably in part at least from Russia. Before moving to this site they were at Russia Wharf in Trundley's Road, further down the canal. Because it had quite a narrow frontage the Archangel Wharf used a complicated system of docks and basins linked to the canal to greatly increase the number of barges that could load and unload timber simultaneously. Before Dolton & Co. turned it into a timber yard the land had been a field belonging to Coldblow Farm. The buildings with the tall chimneys in the bottom left corner were the Key Glass Works, which had taken over this section of the canal bank from the Coldblow Pepper Mill. The Archangel Wharf was even more closely hemmed in by railway lines than the Mazawattee factory. On its west side, at the bottom of the picture, was a branch of the East London Railway running into New Cross Gate. On the west side was the London and Brighton main line and, cutting across below it, the Deptford Wharf Branch (see opposite). Its lifting bridge across the canal can be seen nearly opposite the Mazawattee factory.

This wide-ranging view of the centre of Blackheath in the mid-1920s shows the eastern end of the Holly Hedge House enclosure (see p. 129) at bottom left, part of Greenwich Park top left, and most of Blackheath Vale top right. Top centre are Whitefield's Mount and Whitefield's Pond, the latter now very nearly a lost feature of the Heath. The main interest of the picture is in the bottom right corner, which features good specimens of Blackheath domestic architecture of the eighteenth and nineteenth centuries. The area had been divided between the gardens of three eighteenth-century houses, the Knoll, the Pagoda, and the Orchard. The Knoll is just out of sight at the bottom of the picture. The houses that are visible there, at the top of Granville Park, had been built over the Knoll gardens in the 1850s and 1860s. The eight pairs of large semi-detached houses above Granville Park are Aberdeen Terrace and Haddo Villas, the latter now part of Eliot Vale. There were built in the late 1850s over the garden of the Pagoda, which had grown from a mid-eighteenth-century summer house into a substantial villa. It can be seen sheltering modestly behind the huge Aberdeen Terrace houses, almost surrounded by trees. The large, nearly square enclosure in the right centre of the photograph was detached from the Heath in the 1780s, and soon became the garden of the substantial house known as The Orchard. That can be seen breaking the building line of the houses on the nearest face of the enclosure. The Orchard was demolished in 1965 and replaced by a block of flats. Its garden had been lost in the 1890s, when most of the fine detached houses on its southern, eastern and western edges were built in Eliot Vale, Orchard Gardens and The Orchard.

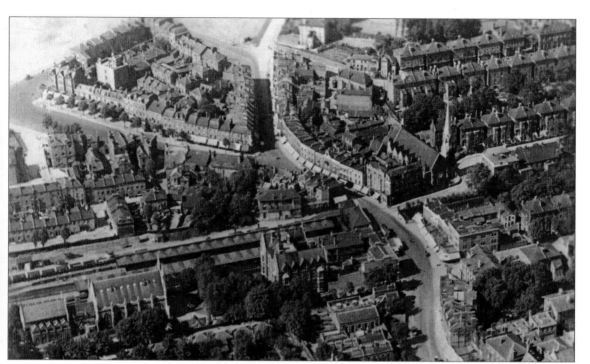

The whole of Blackheath Village is neatly framed within the borders of this mid-1920s aerial photograph. Lee Road, entering the picture bottom right, drops down into the trough of Blackheath Village, which swings left past the station (opened in 1849) and divides into the two roads that climb up to the Heath. Tranquil Vale is the one on the left. Montpelier Vale points directly to the top centre of the picture, where its continuation, Montpelier Row, bends gently to the right. Even in well-preserved Blackheath a number of the prominent landmarks seen here failed to survive the wear and tear of the twentieth century. The large building at the bottom of the picture, just right of centre, was the old Blackheath Proprietary School, built in 1831. The school had closed in 1907, but the building survived until 1936 as the premises of the Blackheath Press, which published the *Blackheath Local Guide*. Its replacement in 1937 by Selwyn Court, a block of flat and shops in a style wildly out of keeping with the rest of the village, was the spark that ignited the preservation movement in Blackheath. But no amount of local zeal could ward off the horrors of the Second World War, which changed the village even more dramatically. The large Gothic building bottom left was the Blackheath Congregational Church, opened in 1853. It was badly damaged during the war, and had to be largely rebuilt in the 1950s. It is now used as offices. The hall behind, added in 1889, which was less severely damaged, has become a nursery school. The large church with the tall spire to the right of the picture was the Wesleyan Methodist Chapel, Blackheath Grove, which was one of the dominant features of the village from 1864 until its destruction in 1945. The V2 rocket that accounted for it also shattered many of the surrounding houses and shops. One of the buildings that arose on the cleared site in 1961 is now the Blackheath Village Library. Large buildings that passed virtually unscathed through the twentieth-century ordeal include the Conservatoire of Music, bottom right, which was completed in 1896, the Blackheath High School for Girls in Wemyss Road, top right, built in 1879, and Winchester House, to the right of the Congregational Church, which had been built in 1857 as a school for the sons of missionaries. It was being used as flats and offices in the mid-1920s, but is now the headquarters of the Church Army.

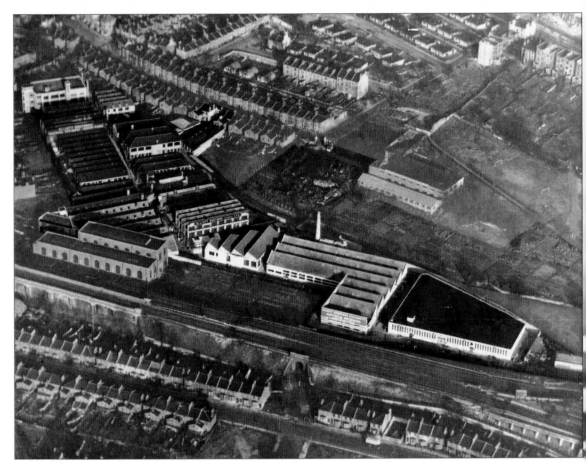

The main feature of this late 1940s photograph, highlighted in the print, is the Century Works, the Lewisham factory of Elliott Brothers, the electrical engineers. It stood north-west of Lewisham station, between the railway line and the Ravensbourne. The end of platforms 2 and 3 can be seen in the bottom right corner. There was a double reason for the 'Century Works' name: the factory was built in 1900, on the threshold of a new century, and just a hundred years after the founding of the firm in the City of London. William Elliott started in business as a scientific instrument maker. His sons, the 'Elliott Brothers', specialised in the manufacture of electrical equipment. By 1900 the connection of the founding family with the business had ended, but in spite of mergers the well-known name was retained. The original factory consisted of the mass of black roofs to the left of the picture. The buildings in the centre and on the right were added in the 1920s and '30s. An industrial area close to a railway junction naturally suffered heavy bombing in the Second World War, but the Elliott factory itself escaped remarkably lightly. All around it bombsites can be seen, some of them occupied by prefabricated houses of various types. But oddly enough the most prominent derelict area, the dark square of rubble nearly in the centre of the picture, was not the result of bomb damage. That was the site of the Lewisham Silk Mill, which had been demolished in 1937 or soon after. Note its ornate gateposts, which still survive at the bottom of Morden Hill. In the foreground is Thurston Road, with a water tank on one of its bombsites. Above the factory is the undamaged Connington Road. Between that and Lewisham Road, which cuts across the top right corner, is an area where very little survived the war, and almost nothing the peace. The Sydney Arms, the white building at the corner of Lewisham Road and Morden Hill, is practically all that remains. One of the big Lewisham Road houses on the right may have been what Edith Nesbit had in mind as the home of the Bastable family in *The Treasure Seekers*. The Century Works was closed in the 1980s, and housing now covers the site.

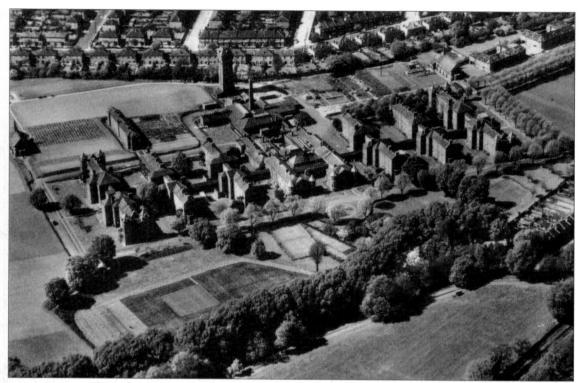

This late 1940s aerial view is dominated by Ladywell Lodge (see p. 125), which had been opened as the St Olave's Union workhouse in 1900, but fifty years later was being used as a London County Council old people's home. The land on which the workhouse was built had formerly been known as Slagrave Farm. In the foreground, cutting across the bottom right corner, can be seen a short section of the railway line between Ladywell and Catford Bridge, which was opened in 1857. The end of Malyons Road appears on the right edge, and between the railway and Ladywell Lodge a part of the park then known as Ladywell Recreation Ground, but now as Ladywell Fields. The belt of trees between the park and Ladywell Lodge follows the line of the River Ravensbourne. In the background is part of the estate built by J.W. Heath & Sons over the fields of Bridge House Farm. Its main artery is Chudleigh Road, which is seen running along the boundary of Ladywell Lodge, divided from it only by the winding course of a minor tributary of the Ravensbourne. The roads turning off to the north are, from right to left, Arthurdon, Gordonbrock, Amyruth, and Henryson. Heath & Sons began work at the beginning of the twentieth century at the eastern end of the estate, and the terraces on the far side of Chudleigh Road are part of the original Edwardian development. All the semi-detached houses date from a second surge of building that began in the late 1920s and continued throughout the 1930s. The Heath estate and Ladywell Fields have not changed much in the last sixty years, but the area between has been transformed by the demolition of nearly all of Ladywell Lodge in the 1970s and '80s, and its replacement by housing. The water tower survives, as does the nearer half of the administrative block in the centre of this picture, but most of the old workhouse has given way to the roads called Dressington Avenue, Rushey Mead, Lions Close, and Foxborough Gardens.

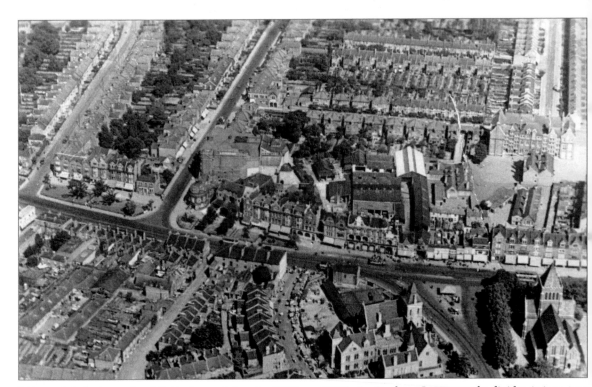

This aerial photograph of Catford was taken in 1924 or 1925. As Rushey Green neatly divides it into two parts, I will describe the far or east side first, then the near or west side. The turnings shown off the east side of Rushey Green are Ringstead Road, on the left, and Brownhill Road. The Sangley Road corner is just off the right edge of the picture. In Brownhill Road, note that the Salvation Army's tin tabernacle opposite Plassy Road (see p. 37) had been demolished, but the present citadel, built in 1925, had not yet replaced it. The huge building on the south side of Brownhill Road was the Lewisham Hippodrome music hall, with its distinctive circular booking hall on Rushey Green. Next south from that was the Queen's Hall cinema. Both were to be demolished in 1959. The large shed-like buildings (one with a white roof) south of the Hippodrome were once the depot of the horse trams. After electrification, and the extension of the tramlines to Forest Hill and Southend Village, the old depot was vacated, and by 1924 it had become the garage for Timpson's great fleet of charbancs. Between that and Rushey Green was the ornate Black Horse & Harrow pub, now the Goose on the Green. South of Timpson's garage, and on the right edge of the picture, was Plassy Road School, which fell a victim to the Catford one-way traffic system, and was demolished in the 1990s. On the near side of the picture, the building on the far right, at the corner of Bromley Road and Catford Road, was St Laurence's Church. To its left, on the other side of Catford Road, was the even more Gothic old town hall. Both of these were to be swept away in 1968, as part of the town hall redevelopment scheme, which quickly led to the erection of the Civic Suite, and twenty-five years later to Laurence House, the council offices now on the site of the church. In 1924 the area between the old town hall and Rushey Green was occupied by a council depot and the former fire station, opposite the Black Horse. Eight years later both were to be replaced by the New Town Hall, now the Broadway Theatre and Town Hall Chambers. Springfield Park Crescent, later Catford Broadway, on the north side of the town hall, had a flourishing street market in 1924. The stalls can be seen along the south side. The next turning from Rushey Green, opposite the Queen's Hall cinema, was Willow Walk, which has now become the entrance to the Catford Shopping Centre. On its north side note the London City Mission chapel, seen in more detail on p. 46. The large range of buildings behind the chapel, in the bottom left corner of the picture, was Robert Morley's piano factory. This photograph displays an area in which, while many of the shops and small houses survive, nearly all the prominent buildings are now only a fading memory.

INDEX

Aberdeen Terrace 136
Addey and Stanhope School 53
Adelaide Avenue 112
Albert Road 81
Albion 21
Albury Street 68, 131
Alexandra Terrace 116
Algernon Road 86, 100
Allen's Green 21, 33
Alverton Street School 130
Amroth Close 36
Archangel Wharf 134, 135
Archer, Thomas 39
Army Service Corps 122
Ashley, H.V., and Winton
 Newman 119
Athlone Court 42
Austen, Francis Motley 35
Balcarres 31
Balsdon, John 91
Barclays Bank 16, 95
Baring Road 66
Barnes, George 115
Beard, J. Stanley 78
Beckenham Hill Road 74
Beckenham Hill station 63
Beech House 119
Beeston & Co. 98
Belgrave Villas 52
Bellingham Estate 89, 110, 122
Bellingham station 110, 122
Belmont House School 51
Berlin Road 61
Bermondsey Military Hospital
 125, 139
Beulah 30
Black Horse & Harrow, Rushey
 Green 61, 140
Blackheath 74
Blackheath Concert Halls 19
Blackheath Congregational
 School 137
Blackheath Conservatoire of
 Music 137
Blackheath District Traders'

Association 20
Blackheath Grove 137
Blackheath High School 49, 137
Blackheath Hill 19, 132
Blackheath Hospital 51
Blackheath Methodist Church
 137
Blackheath Proprietary School
 23, 137
Blackheath Road 132, 133
Blackheath Vale 136
Blackheath Village 137
Blackheath Wesleyan Church 19
Blackhorse Bridge 130
Blacklands Road 63
Blake Street 131
Blessington Road 30
Blomfield, Sir Arthur 38
Bloomville 32
Bonner, Horace T. 79
Boughton, William 108
Bridge House 22
Bridge House Farm 58, 139
Brightfield Road 64
Broadway Fields 133
Broadway Theatre, Deptford 4
Brockley Cemetery 18, 106
Brockley Grove 81
Brockley Hall 81
Brockley Park 41
Brockley Road 18, 81, 98
Brockley Road School 18
Bromley Hill 25
Bromley Hill Cemetery 25
Bromley Road 24, 25, 58, 62
Brook House 33, 105
Brookmill Road 113, 116, 133
Brownhill Road 37, 43, 117, 140
Brownhill Road Baptist Church
 43
Bull and Butcher, Watergate
 Street 80
Burnt Ash Hill 32, 85
Burnt Ash Road 32
Buses 112

Cable, Walter 116
Camden Villas 95
Campbell, William Hume 49
Canadian Avenue 61
Capitol, London Road 78
Carrington House 113, 132, 133
Carter, Bertram 29
Catford Broadway 140
Carford Cycling Club 123
Catford Gospel Mission 123
Catford Hill 24, 116
Catford Hill Baptist Church 43
Catford Methodist Free Church
 37
Catford Road 109
Catford Shopping Centre 46
Catford/Southend FC 25
Cedar Lodge 29, 83
Century Works 138
Chiesman Brothers 70, 95
Chinbrook Crescent 27
Chinbrook Road 27, 89, 90
Christ Church, Deptford 132
Christ Church, Lee 51
Chudleigh Road 139
Church House 38
Church Missionary Society 50
Church of the Assumption 41
Clarendon Road/Rise 69
Cleopatra Grove 117
Clifford House 33
Clifton Hill/Rise 80
Clyde Street 101, 119
Clyde Villa 36
Coldblow Pepper Mill 135
Colfe's Grammar School 53
College View, Catford Hill 24
Collins, A.H. 71
Collins Square 102, 114
Comerford Road 18
Conisborough Crescent 35
Connington Road 138
Cooper, Henry 78
Corbett Estate 43, 45, 55, 88,

104, 117
Cottesmore, Morley Road 87
Courthill Road 42
Cowdrey, Colin 70
Cranford, Albert William 102
Craven House 27
Creek Road 44, 131
Crow, John 28
Crystal Palace beerhouse 61
Crystal Palace District Electric
 Light and Supply Company
 120
Culverley Road 88
Cutler, Samuel 83
Czar Street 75

Dacre Park 114
Danescombe, Winn Road 85
Dell Lodge 29
Dalrymple Road 18
Darling, Charles, Lord 81, 108
Darling Road 81
Dartmouth House 83
Dartmouth Road 47
Dartmouth Row 19, 29, 83, 99
Davies, J.P. and Co. 95
Densham, John Lane 134
Deptford Boy Scouts Association
 71
Deptford Bridge 16, 17, 132, 133
Deptford Bridge Mill 92, 132, 133
Deptford Broadway 16, 17, 94,
 132, 133
Deptford Central Hall 44, 131
Deptford Church Street 39, 132,
 133
Deptford Conservative Working
 Men's Club 108
Deptford Creek 132
Deptford Dockyard 130
Deptford Fire Station 105
Deptford High Street 17, 41,
 131, 132
Deptford Municipal Playing Fields
 133
Deptford Pumping Station 132
Deptford Tariff Reform Club 127
Deptford Wharf 92, 130, 134,
 135
Dolton, Bournes, and Dolton 135
Dover Castle 17
Downham Estate 118
Downham Tavern 118
Downham Way 118
Dowson, Ernest 117

Drysdale Road 99, 115
Dubois, Ernest Arthur 30, 96
Dudman's Dock 92
Duncan, Leland 69
Dylan's, Lewisham High Street 69

East, Philip 31
Edgcumbe 28
Edney, Thomas & Rosamond 120
Edney Street 120
Edward Street 119, 131
Egerton, William 58
Eliot Vale 136
Elliott Brothers 138
Elm Lane 59
Eltham Road 31, 72
Emmanuel Church 116
Empire Day 56
Ennersdale School 56
Evelyn Street 101, 105, 128,
 130, 131
Exbury Road 59

Fairfield Road 90
Falkland, Lady 35
Falkland House 35
Faulkner Street 75
Folkestone Gardens 134
Folly Pond, Blackheath 74
Fordham Park 80
Foreign Cattle Market 80, 130
Forster, Samuel 35
Foxberry Road 98
Frankham Street School 132

Gardiner & Co. 16, 17, 133
Gatcombe, Joseph Williamson 85
Geoffrey Road 28
Gilbert, George Felix 93
Gilbert, Sir John 93
Gilmore Road 33
Glebe, The 30
Glebe Court 30
Glenton Road 52
Globe Cinema, Staplehurst Road
 97
Goldsmiths' College 28, 48, 71
Good, Charles 80
Granville Park 136
Granville Road 70
Green, William 117
Green Man, Southend 62, 63
Greenaway and Newberry 40
Greenwich High Road 132, 133
Greenwich Union Workhouse

122
Grenada, Sydenham Road 77
Greyhound, Kirkdale 67
Grinling Place 101, 131
Grote's Buildings 82
Grote's Place 82
Grove Cottage, Sydenham Road
 73
Grove Park Dairy 85
Grove Park Hospital 122
Grove Park House 27
Grove Park station 112
Grove Street 130
Grove Street School 54, 130
Grundy, Charles H. 40
Guntrip, Thomas 35
Guy, Albert Lewis 79

Haddo Villas 136
Hall, Edwin 106
Hare & Billet 64, 82
Hare & Billet Pond 64
Harp of Erin 131
Hart, Sydney 104
Harton Street 133
Hatcham Liberal Club 109
Hatcliffe's Almshouses/Charity
 61, 84
Hay, Will 18
Haycraft's ironmongery 133
Hazell, Edward 62
Heath, J.W. & Sons 139
Heather Road 85
Hedgely Street School 54
Hilly Fields 65, 112
Hinks, George 99
Hither Green Congregational
 Church 42
Hither Green Hospital 15, 106
Hither Green Lane 15
Hither Green Library 104
Hither Green station 97
Holbeach Road School 55
Holland's Distillery 133
Hollebone family 34
Hollett's forge 114
Holly Brow 26
Holly Hedge Bungalows 128
Holly Hedge House 128, 129,
 136
Honor Oak Road 36
Hopton, Henry 104
Horniman Drive 36
Horniman's Museum 26
Humphrey, Edgar 73

Idonia Street 119
Inwin, Thomas 35

Jeall, William 100
Jerrard, Samuel 69, 86
Joiner's Arms, Lewisham High Street 69
Joy Cottages, Brockley Grove 81

Kennard, D. & R. 97, 100
Key Glass Works 135
Keylock, William John 28
Killearn Road 88
King of Belgium, Albury Street 68
King of Prussia, Albury Street 68
King's Church 43
King's Parade 97
Kirkdale 26, 67
Knapton & Sons 24
Knight, Athro 52
Knightsville College 52
Knill family 106
Knoll, The 136

Ladywell Fields 126, 139
Ladywell Lodge 125, 139
Ladywell Recreation Ground 126, 139
Ladywell Road 58, 100, 104
Lamerton Street 131
Lampmead Road 84
Lansdowne Place 50
Larch House 119
Lasbrey, Percy Urwick 51
Law, Frederick and Lady Adelaide 38
Leaver, Francis 28
Lee High Road 96
Lee Road 23, 73, 137
Lee Terrace 38, 51, 52, 126
Lee Working Men's Club 73
Lenham Road 84
Lethbridge Road/Close 99
Lewis Grove 96
Lewisham Board of Works 61, 109
Lewisham Congregational Church 42, 69
Lewisham Cricket Club 69
Lewisham Hill 29, 53, 83
Lewisham High Road 18
Lewisham High Street 21, 22, 33, 42, 60, 69, 70, 91, 94, 95, 103, 104, 105, 111, 121

Lewisham Hippodrome 140
Lewisham Hospital 124
Lewisham House 104
Lewisham Methodist Church 95
Lewisham Park 66, 79, 121
Lewisham Police Station 104
Lewisham Rifle Range 118
Lewisham Road 98, 138
Lewisham Silk Mill 138
Lewisham Sorting Office 105
Lewisham station 103, 138
Lewisham Town Hall 61, 109, 140
Lewisham War Memorial 121
Lewisham Way 18
Lewisham Workhouse 124
Lidle, John 120
Lingards Road 69, 87
Lloyd's Place 64, 82
Loampit Vale 94
Loat, Lancelot 99
London & South Western Bank 16
London City Mission 46, 140
London County Council 120, 131, 133
London Regiment 128
London Road 26, 78
Long, Lavinia 52
Longhurst Road 87
Lower Mill, Southend 63, 74
Lucas, Thomas 68
Luffman Road 90

Maberley, Frances Catherine 29
McMillan Street 131
Magnolia House 22
Main, Robert 34
Malyons Road 139
Manor House Gardens 64
Manor Lane Terrace 31
Maple House 119
Mazawattee Tea Company 134, 135
Meadowcourt Road 84
Merchant Taylors' Company 30
Milford Road 46
Mill Lane 113
Miller, Benjamin 33
Montague Avenue 112
Montpelier Vale 19, 137
Montreux Cottage 26
Morden Hill 29, 138
Morley Road 87
Morley, Robert (pianos) 140
Mott, Raymond Culver 32

Mountsfield Park 72
Mumford's Mill 132, 133

National Dwellings Society Ltd. 117
Nesbit, Edith 138
New Cross Cigar Stores 16
New Cross Gate 16
New Cross Gate station 110
New Cross Road 53, 108, 110, 127, 132
New Cross station 110
New Cross Tram Depot 127
New King Street 131
New Parade Café 22
North, Richard 41
Northbrook Park 66
Northbrook Road 31
Northbrook School 54
Nursing Sisters of St John the Divine 107

Oak Lawn 30
Obelisk Buildings 94
Obelisk Picture Palace 76
Old Centurian 17
Old Road 48
Oram, Miss 52
Orchard, The 136
Orchard Gardens 136
Oxford House 33

Pagoda, The 136
Paris House 70
Park, F.J. 98
Park, The (Southend) 35
Park Hospital 15, 106
Park Terrace 23
Park Villa 33
Paton, James 31
Payne Street 119
Pearce, George Edward 69
Penn, John 132
Pentland House 48
Peppercorn, Joseph 94
Perriam, William 69
Perry, Jacob 57
Peter Pan's Pool 63, 74
Phillips, Samuel 35
Pitt, John James 101
Plassy Road School 97, 140
Polsted Road 34
Pool River 59
Portmadoc, Chinbrook Road 89
Pragnell, Sir George 72
Private Banks Cricket Ground 61

Pugin, E.W. 106

Queen Street 131
Queen's Hall cinema 140
Queens Road 109
Queen's Street 131
Quentin Road 117

Randlesdown Road 122
Rangefield Road 118
Ravensbourne Club 72
Ravensbourne Park 34, 62,
 116
Ravensbourne Park House 34
Ravensbourne River 59, 60, 76,
 92, 132, 139
Ravensbourne Street 116
Raymont Hall 28
Red Cross 126
Retreat, The (Catford) 55
Ringstead Road 140
Riverston School 31
Robertson, James 25
Robinson, Joseph and Henry
 92
Rocklands 36
Rosamond Street 120
Roselawn 25
Rowley Street 131
Royal Kent Dairy 98
Royal Parade 19
Royal Victoria Victualling Yard
 130
Rushey Green 61, 140

Sainsbury, J. 94
St Christopher's College 49
St Dunstan's College 20, 34
St Germans Cottages, Brockley
 Grove 81
St Helen's Lodge 32
St Hilda's Church 40
St John's Hospital 29, 83
St John's Mission Hall 133
St Joseph's College 52
St Laurence's Church 24, 61,
 97, 140
St Luke's Church 128, 130
St Margaret's Church 38
St Mary's Church 38
St Michael's Church, Deptford
 134
St Mildred's Road 23

St Olave's Union Workhouse
 125, 139
St Paul's Church, Deptford 39
St Paul's Church, Waldenshaw
 Road 36
St Peter's Church 40
St Peter's Villa 28
St Swithun's Church 15
St William of York 41
Salisbury, Lewisham High Street
 95
Salvation Army 37, 140
Sandhurst Road School 55
Sangley Road 97
Saunders, Robert 35
Sayes Court 75, 130
Sayes Court Recreation Ground
 54, 71, 130
Scotch House 16, 17
Sears, Alan N. 43
Selwyn Court 137
Shillito, William Francis 36
Shooters Hill Road 74
Silver Jubilee (1935) 20, 75
Simpson, Henry 133
Sinden, Frank Sydney 76
Slagrave Farm 139
Slee, Charles Welborne 35
Smiles, Samuel 83
South Circular 23, 24, 32
Southend Lane 89
Southend Park 89
Southend Village 74
Spangate 23
Sportsbank Hall/Street 123
Springfield Brewery 120
Springfield Park Crescent 140
Squire & Earp 26
Stainton, Henry Tibbats 72
Stanhope's School 53
Stanstead Road 24
Staplehurst Road 97
Stocks, Charles Edmund 50
Stone, E.A. 121
Surrey Canal/Docks 130, 134
Swan, Albury Street 68
Sydenham County Secondary
 School 47
Sydenham Hill 26
Sydenham Hill Estate 120
Sydenham Road 73, 77
Sydney Arms 138
Thurston Road 138

Tilling, Thomas 82, 112
Timpson's garage 140
Torridon Road 42, 45, 104
Torridon Road Library 104
Torridon Road Methodist Church
 45
Trams 111, 127
Tranquil Passage 19
Tranquil Vale 20, 102, 137
Trinity Almshouses 39
Turner Road 114
Tyrwhitt Road 81

Union Street 68
Upper Mill, Southend 57

Vanguard Street 133
Verdant Lane 60
Vicar's Hill 86

Walker, William 33
Watergate Street 80, 131
Watson's Street 107
Watt, James 24, 88
Webb, Sir Aston 132
Weigall Road 31
Wellington Street 131
Wemyss Road 19
West Bank, Lewisham Hill 83
West Grove 19
West Kent Yeomanry 123
West Lodge 29
Westcombe House 49
Westhorne Avenue 32
Westwood Park 36
Whitbread Road 18
White House Cricket Club 58
White House Farm 58
Whitefield's Mount/Pond 136
Whitefoot Lane 60
Wickham Road 28
Willow Walk 46, 140
Winchester House 137
Winn Road 85
Wood, Miss 52
Workhouse Lane 75
Worsley Bridge Road 89
Wyberton House 52

Yeatman-Biggs, Huyshe Wolcot
 83

Zurhorst, Mrs 32